T0345838

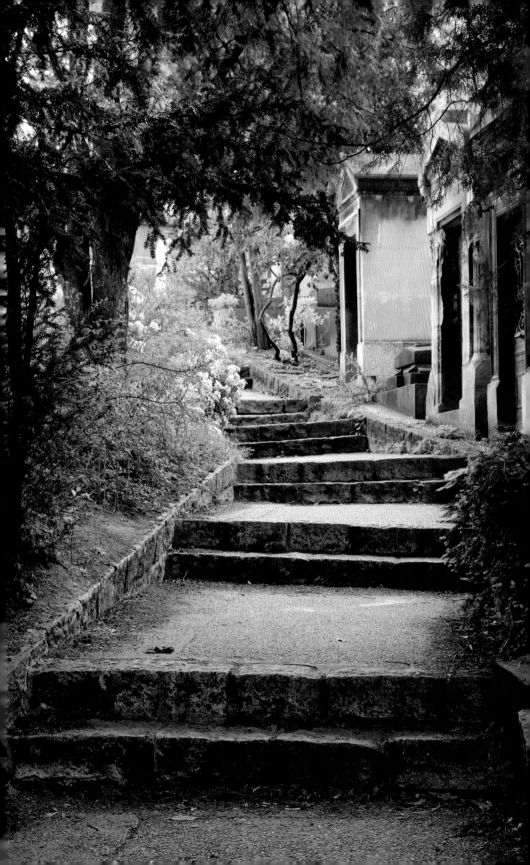

CITY OF IMMORTALS

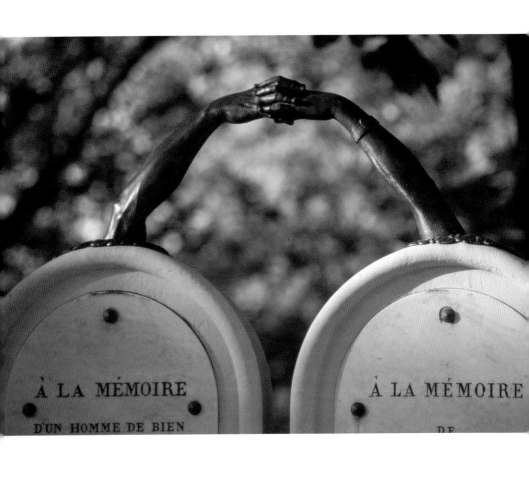

CITY OF IMMORTALS
PÈRE-LACHAISE CEMETERY, PARIS

Text and principal photography

Carolyn Campbell

Contributing photographer

Joe Cornish

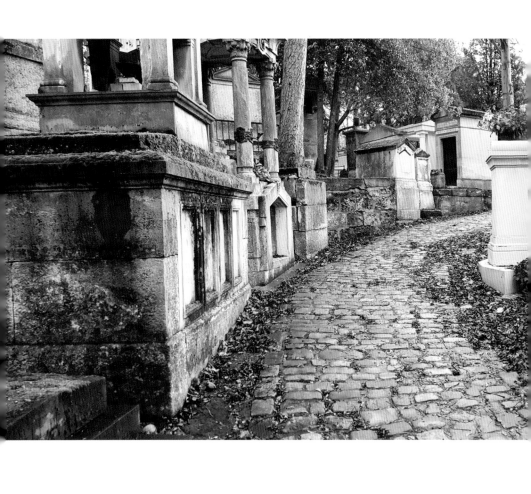

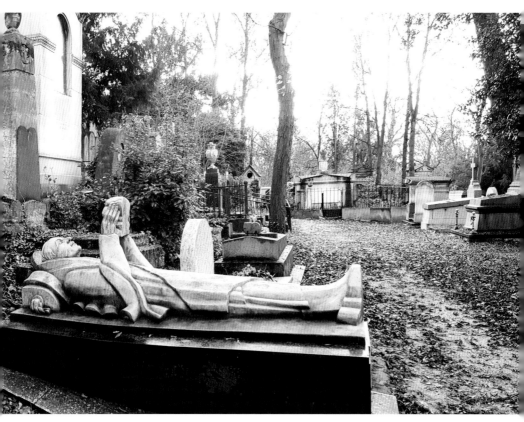

ABOVE: TOMB OF ARBELOT ON AVENUE DELILLE, DIVISION 11.

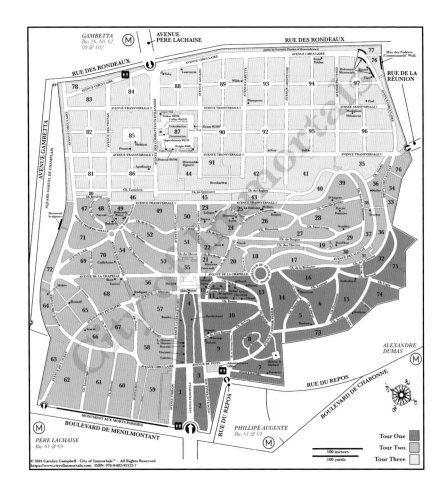

CONTENTS

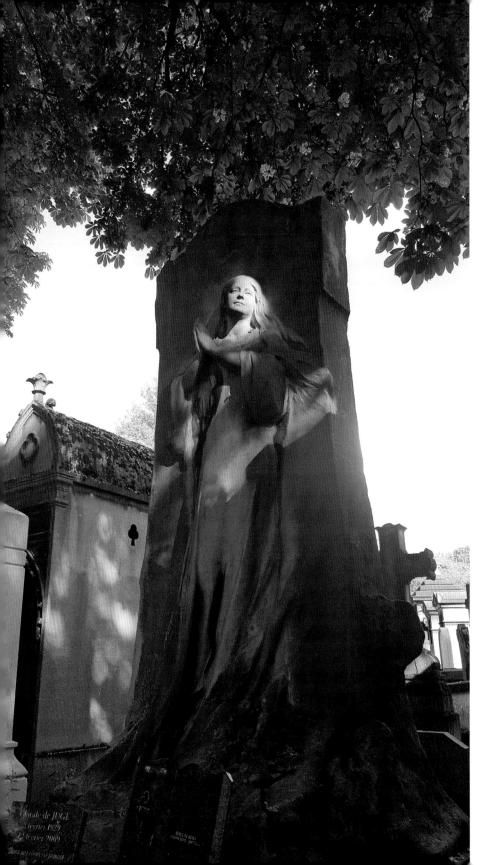

INTRODUCTION

My first encounter with a funerary ritual was frightening yet beautiful. My mother told me at age eleven that my grandfather, a lieutenant colonel in the army, had died and that we were going to attend his funeral at Arlington National Cemetery. I sensed it was an important occasion because she asked me to put on my favorite dotted Swiss dress and black patent leather shoes. As members of the family, we rode in a limousine. The women wore long black veils covering their faces and leaned on the arms of the men. At the cemetery, several brawny soldiers in uniforms with gold braid and shimmering swords lifted the casket from the back of a hearse and put it onto a shiny black wagon called a caisson, a gun carriage drawn by six gray horses.

As the procession moved along the winding road, workers stopped what they were doing and stood at attention. Everything was still except the wind stirring in nearby trees, which tossed the horses' manes and teased the edges of the flag draped over the casket. We all walked up a grassy hill to the graveside. I spotted the large hole underneath the metal cradle where the casket was placed. A short eulogy by a military chaplain was followed by three soldiers who took the large flag from atop the casket and, in amazing synchronized movements, folded it into a neat triangular bundle that one of them handed to my grandfather's widow.

Being a precocious kid, I tried to get the stern-faced soldiers to smile by making faces at them. I've always been the clown in the family at serious moments, but my mischief came to an abrupt halt with the explosion of a multigun salute, and the lone bugler's playing of "Taps." The horn's mournful cry echoed throughout the cemetery. Frightened, I grabbed my mother's hand as we both wept. This was my initiation into grief.

My father's deathbed plea was alarming in its urgency: "Carolyn, never put off your dreams." He died of cancer at age sixty-four, having just retired after thirty-five years of work for the federal government. He never realized his own dream of being a writer.

OPPOSITE PAGE: LIFE SIZE RELIEF OF FRENCH OPERA SINGER MARIE-CAROLINE CARVALHO BY SCULPTOR ANTONIN MERCIÉ ON AVENUE CIRCULAIRE, DIVISION 65.

Years later I started a meditation practice on death and impermanence that put me more in touch with life and the fact that death is with us every day, though cemeteries and burials did not hold any particular interest for me. In 1981, I was director of Public Relations and Special Events at the Corcoran Gallery of Art in Washington, DC. During a staff meeting, the conservator who moonlighted as a travel agent offered me a ticket to Paris. It would be my first trip to France.

The next week, an artist at an exhibition opening said, "You need to visit Père-Lachaise Cemetery in Paris. It has hundreds of memorials to creative souls." "Really?" I asked. "Isn't Oscar Wilde one of your idols? My ancestor, Sir Jacob Epstein, sculpted the monument marking Wilde's burial place there. You have to see it." I now had my first destination.

I told my dinner date, Jerome, a handsome graduate student from Lagos, my plan to visit the famous cemetery. He shot me a look of concern and said in his sexy British accent, "You must be very careful. There are a lot of unsettled spirits in a graveyard. You need safeguarding." I thought he was over-reacting. He described a strange ritual that he wanted to perform on me. "It will give you a cloak of protection. Not all souls rest in peace."

He launched into a list of what we needed: "A live chicken. Please get a roll of dimes from the bank, and I will purchase bottles of champagne."

The next day at my apartment, after wringing the chicken's neck, he made a deep slice in its chest and squeezed a stream of blood into a bowl. I heard the glub-glubbing of champagne being poured in the bathtub, followed by the plinking of dimes. Dipping his fingers in the scarlet ooze, he smeared my forehead, shoulders, and arms with symbols. His touch was warm, but the goo was sticky and revolting. "Now please sit in the tub."

I wore a Speedo as I stepped into the tingly concoction; he poured champagne on my head and dropped coins over me while reciting an incantation. The mood got serious when I closed my eyes and an electric sensation shot through my body. Jerome then abruptly announced, "We are finished. Please do not shower until this evening."

I grew up around great architecture and urban planning as envisioned by a French designer, though at the time I didn't know it. I flew my kite on a grassy hillside under the shadow of a towering 550-foot marble obelisk, the Washington Monument; raced the football-field length of the marble Reflecting Pool on the National Mall; and took my first art classes in the nearby Beaux-Arts Corcoran Gallery of Art.

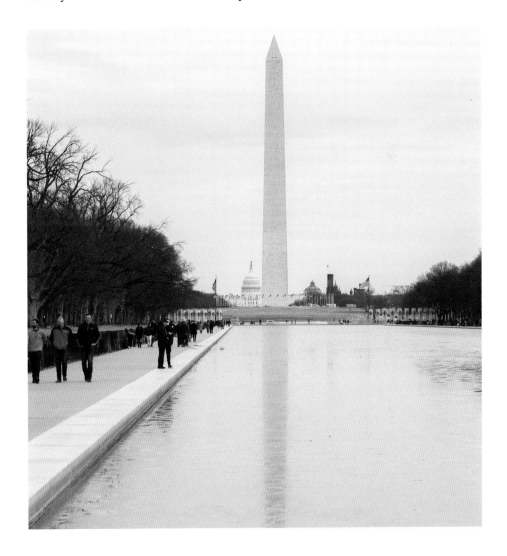

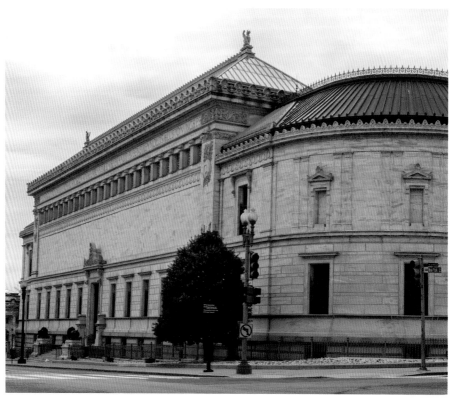

CORCORAN GALLERY OF ART.

It was in high school that I learned that Washington, DC, was planned by a Frenchman, Pierre Charles L'Enfant; he was responsible for the elegant design of the Mall, with its wide boulevards for strolling and gardens bordered at one end by the Potomac River. It formed the perfect backdrop for great monuments celebrating history and culture.

Paris, like Washington, is a city with a river that runs through it. The many bridges crossing the Seine, which snakes its way through the French capital, are a tribute to engineers who possessed a grand sense of style.

Intrigued by French architecture and urban design, which I studied in depth at college, I embarked on a first-person exploration of how the City of Light was designed, and discovered the genesis of its legendary cemetery. One night in Paris, taking a boat ride down the Seine and seeing Notre Dame and the Eiffel Tower lit up, we passed under the Pont Neuf, where I saw the tall, sculpted medallions emblazoned with the initial "N" for Napoléon Bonaparte on the

side. I understood how this brilliant use of graphic design and typography was an apt celebration of the famed emperor. In yet another display of French creativity, the bridge illustrated that art and life are inseparable. I stayed in a friend's home on Rue des Batignolles in the seventeenth arrondissement, necessitating a crosstown adventure on my first ride on the Paris Metro to visit Oscar Wilde's tomb. I arrived at the Père-Lachaise stop in the twentieth arrondissement and emerged from the underground on Boulevard de Ménilmontant. From there I spotted the tall cemetery wall with chapel spires peeking out over the battlements.

In my quest to find Wilde (which on that first visit I did not accomplish, getting distracted by the immensity of the 107-acre labyrinth), I fortuitously happened upon a tour guide who was talking to an enthralled group about the cemetery's founding by Napoléon Bonaparte and its revolutionary design. She also told us that the cemetery had become a beloved landmark and the fourth most visited site after the Arc de Triomphe, Notre Dame, and the Eiffel Tower. As she enumerated the cultural icons buried there, I became intoxicated with a world of funerary art and history where renowned artists, writers, actors, filmmakers, and musicians rested.

During that visit to Père-Lachaise, I found no signs of negativity; in fact, the entire cemetery appeared to be a comforting sanctuary. I shook my head, remembering my body covered in chicken's blood and champagne.

Toward dusk, I left the cemetery. Riding the automated people mover in between subway stations, I leaned against the illuminated sidewall. Suddenly, I heard a loud crash. The fluorescent panel began to flicker. Within seconds, I heard loud male voices arguing and felt the treadmill shaking under my feet. There was a young couple about fifty feet away. The man took a protective stance in front of the woman. I then saw three figures striding toward us.

I felt incredibly vulnerable, traveling alone at night with valuables in my purse. What an idiot, I thought. Why hadn't I taken a cab?

A trio of young thugs—one sporting a Mohawk, another with a shaved head and neck tattoos, the third in a greasy ponytail and skull earrings—began shoving, then punching the young man. There were no police in sight. The couple crumpled to their knees, the girl sobbing. The men laughed loudly, then careened in my direction.

I steeled myself for the worst, imagining being battered, robbed, and left to die in the underground. My breathing was shallow. I willed myself to disappear. The heavy steps of the men's boots made the flooring sway violently, yet I was oddly motionless. They were now alongside me. I felt their menacing energy and could smell their musky odor. Then, remarkably, their dark presence went right past me, as if I were indeed protected. I understood then it was not the dead I needed to fear but the restive living.

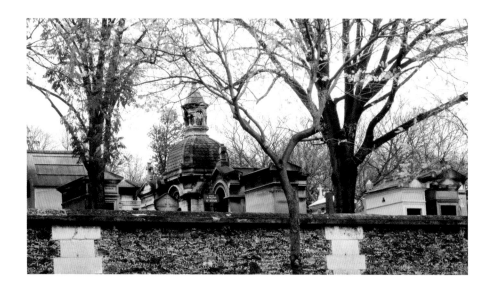

When I eagerly planned my second trip to Paris late in 1982, having decided to write about and document the extraordinary necropolis, I commissioned British photographer Joe Cornish to join me in creating a nostalgic photo album of the Ritz of Elysium. "I was a rookie photographer and assumed at the time that the lack of a publisher was not a problem," Joe later told me. We embarked unknowingly on a trip that would plant the seeds of his passion for landscape photography and a memorable collaboration for me—a decades-long journey for us both.

In 1997, I called Joe again. This time there was interest from a publisher. There was still no budget, but we needed more images. Joe responded with the same eagerness, "Carolyn, my affection for the place remains undimmed." In 2016 after honing my own research, writing, photography, and art direction skills, plus having made several additional visits to the cemetery, I created an illustrated, custom map and GPS app for touring the famous artists' tombs.

The next time I called Joe, it was with a solid publishing offer in hand. I asked if he could come to Paris one last time. Joe replied, "Maybe the third time is the charm."

So, thirty-plus years later, Joe and I found the subtle wonders and frights of this finest of all final worldly destinations still called to us as intensely as before. Joe captured the mood perfectly, "As much as the image-making opportunities, it was contemplating the nature of life and death that made this, for me, such a poignant experience of the point of no return." Then he quipped, "I sure hope we might publish our work about Père-Lachaise before we are interred there."

We invite you to join us on this journey. Whether you are an armchair traveler, Francophile, fellow taphophile (cemetery lover), art and architecture enthusiast, curiosity seeker, or a tourist planning a trip to Paris, I hope that you too will become fascinated with the stories told through the tombs of the immortals. May you enjoy astonishing adventures in this grandest of all graveyards.

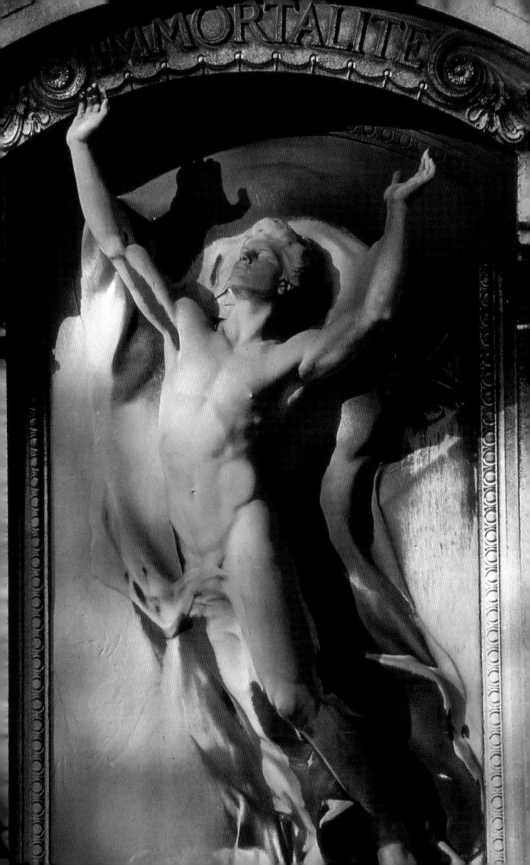

IMMORTALITÉ

CHAPTER ONE

CITY OF IMMORTALS

I SELDOM GO OUT, BUT WHEN I FEEL MYSELF FLAGGING I GO OUT AND CHEER
MYSELF UP IN PÈRE-LACHAISE...WHILE SEEKING OUT THE DEAD I SEE NOTH-
ING BUT THE LIVING.

—HONORÉ DE BALZAC

Imagine it's the year 1780 in Paris, and you're sitting down with family and
friends to a modest meal. Things are bleak due to a series of poor harvests
in the area, which has led to soaring bread prices and food riots. Though
the times are stressful, France is a country where eating is a pleasure rather
than just a means to give the body nourishment, so the group is grateful for
what they have, including one another. Dinner is interrupted by a deafening
roar as the neighboring cellar wall of the *cimetière des innocents* collapses,
spilling an avalanche of 2,000 corpses into your apartment building.

Centuries of war and plague had already filled the catacombs and church
graveyards—the traditional burial places operated by the church—creating
a massive historical mulch in places like the *cimetière des innocents*. The
eighteenth-century Parisian engineers had overlooked one significant
question in their urban design scheme—what to do with the ever-increasing
population of the dead? This is where our story begins.

In the years prior to Père-Lachaise's founding in 1804, Paris was rocked by
terror and anarchy, marked by the Revolution and the executions of Louis
XVI and Marie Antoinette. Though Paris would ultimately triumph against
her enemies, the city was weary. Yet mobs, also angry at how the clergy
lived like aristocrats, destroyed many of the great churches and sculptures.

OPPOSITE PAGE: RELIEF REPRESENTING IMMORTALITY BY SCULPTOR HENRI CHAPU ON THE TOMB OF
FRENCH PHILOSOPHER JEAN REYNAUD.

Through all this strife, the people were anxious for peace. In 1799, her spirit was lifted by a dashing and relatively unknown young general, Napoléon Bonaparte, who was named the new First Consul.

After having been away for many years on military campaigns, Napoléon was concerned with the living conditions of his subjects. He helped institute the sewer system that carried sewage away from the congested and fast-growing neighborhoods of Paris. He also focused on the reinvention and restoration of everything from civil reform to education. This included the creation of the *lycèes* (state secondary schools), civic governance, political restructuring, urban planning, and most notably for culture, including the creation of Europe's largest art gallery, the Louvre or Musée Napoléon. This grand space was to make public the previously private royal collections and to display all the art he had stolen during his many conquests.

The graveyard problem persisted, though, and his constituents demanded a solution. Napoléon laid down the challenge to his city planners: solve the overcrowding.

In 1799 a competition was announced to create new cemeteries on the outskirts of Paris. Though Antoine Quatremère de Quincy, the leading theorist of French neoclassical art and architecture, had proposed concepts in 1790 for an ideal public cemetery (and not the mass graves that followed the Revolution), his ideas had been ignored. He would eventually, however, play a pivotal role in the plans for Père-Lachaise.

At the beginning of the nineteenth century, the suburbs of Paris included forested mountains. Some of the most beautiful were Montparnasse, Montmartre, and in the far eastern section, the tallest mountain, Mont-Louis, named after the Sun King, Louis XIV. The unique topography of these locations, unlike the traditional churchyards, played a key role in the new cemetery mandate, and the stage was set for the awarding of the commission to build a garden-style cemetery, the first of its kind. The winner of the largest commission, the *cimetière de l'Est* (located at Mont-Louis in the east), was architect, urban planner, and landscape designer Alexandre-Thèodore Brongniart—the first architect ever to receive such an unprecedented project.

The church, however, was not pleased. This new burial arrangement meant they might lose their grip on an exclusive market. People believed that burial inside or next to a church offered proximity to God, thereby bettering their chances of getting into heaven—for a price, of course. Nonetheless, the bishops had little power to stop this revolutionary civic proposal since they had to admit that they had run out of room.

Mont-Louis, the largest suburban plot of land, was a former Jesuit retreat located in what is now the twentieth arrondissement. Reverend Friar François d'Aix de la Chaise (1624–1709), the Jesuit confessor to Louis XIV, was a former resident. The popular story is that Louis offered this property, with its elaborate gardens and retreat house, as a strategic gift to his savvy and forgiving Jesuit confessor in the hopes of having his sins removed. The

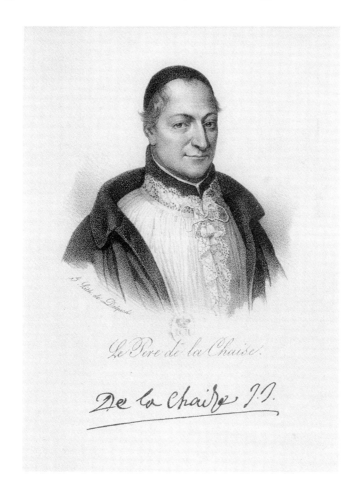

bucolic site was planted with lemon groves, rose gardens, tree arbors, and many winding paths ideally suited to the contemplative life of its former inhabitants. At one historic juncture, however, an attempted attack on Louis XV was traced back to an associate of the Jesuits, and they were banished from the kingdom. By the late 1700s, the land was owned by one M. Louis Baron-Desfontaines.

In 1804, when Napolèon was just thirty-five, the city celebrated his coronation as emperor in Notre Dame. The painter Jacques-Louis David commemorated the ceremony on a monumental canvas. Though Napolèon was soon off to fight more victorious battles in Austerlitz and defeat Tsar Alexander I of Russia, the emperor's appointees were busy implementing his many urban planning designs, including the earliest construction of the Arc de Triomphe and the Champs-Elysées. The next significant achievement was inaugurating the revolutionary new cemetery.

Brongniart created a brilliant design for transforming the mountainous space into a final resting place for Parisians, but it was a hard sell to the populace. Neither the church, which was still not keen on losing business, nor the

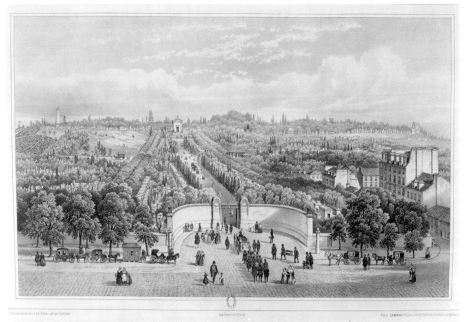

VUE GÉNÉRALE DU PÈRE-LACHAISE. | GENERAL VIEW OF PÈRE-LACHAISE.

parishioners, who did not relish a long trek to the countryside for interment and subsequent visits, were enamored with this new plan. In addition, superstitious people believed that evil and pestilence lurked where the dead were buried.

In stepped Nicolas Frochot, the enterprising prefect of the Seine who had negotiated the sale of Mont-Louis from Baron-Desfontaines for a song. Not only a great wheeler-dealer in real estate, he was also a brilliant marketer who had masterminded the spectacular details of the public coronation event for the emperor, for which architects Charles Percier and Pierre Fontaine, as well as artist Pierre-Paul Prud'hon were commissioned to substantially change the interior of Notre Dame in order to accommodate 20,000 guests.

Frochot had a keen sense of how to appeal to the masses by creating something intriguing. He convinced Napolèon of a plan to win over all the critics as well as the hesitant clientele by naming the cemetery after Père Lachaise, for the popular Sun King's confessor. He launched an inventive real estate promotion with the grand opening of Père-Lachaise Cemetery on May 21, 1804.

A ban on any further burials inside temples, churches, or synagogues was also established that year, per Napoleonic decree, which also created a demand for burial plots. However, it was not enough to sway the people, and only forty four plots were sold. Frochot sought to further appeal to the elite of Paris by purchasing great sculptures to be placed throughout the area, as well as bartering for noble bones to lead the way in being entombed there. In 1817, he acquired the ashes of Molière and Jean de La Fontaine, and successfully negotiated for the remains of the famed and ill-fated twelfth-century lovers, Héloïse and Abélard, whose effigies soon lay atop a granite chapel bier not far from the entrance to the cemetery. The high-end cachet of the place was established, and by 1830 thirty thousand burial sites had been purchased.

Soon, grand mausoleums for the wealthy—designed by leading architects— sprang up amidst the knolls and gardens of Père-Lachaise. Napolèon was a man of the people, and through imperial decree made sure that ordinary citizens would also have a place in Père-Lachaise. Frochot, along with the municipal council, spearheaded by Quatremère de Quincy, created a plan for different burial modes, from a modest plot for the common man to a splendid site for a VIP burial. Since the City of Paris owned the land, and anyone who

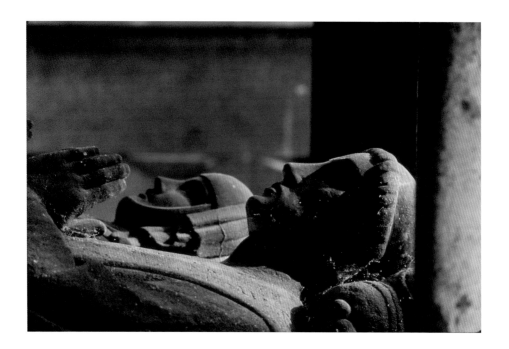

lived within the city's limits could purchase a burial plot, a sliding scale of fees was established. Plots could be rented either for ten or twenty years or as a concession *à perpétuité* (in perpetuity). The rates today for a burial plot *à perpétuité* start at €10,911 (~$12,000 USD).[1] In speaking with cemetery officials, I learned that today's burial arrangements follow the same formula, except that now only approximately 300 spaces become available annually when abandoned concessions (leases for burial plots) are reassigned to new beneficiaries. Currently, one million people are buried in Père-Lachaise. The cemetery's ossuary contains the bones and cremated remains transferred from overcrowded cemeteries across Paris, and counting those, the estimated total climbs to more than two million.

Further conversations with the cemetery's administrators revealed that, unfortunately, some families were shortsighted in relying on their descendants to keep up payments on the plots. In some cases, once the rent was past due and no effort was made to resolve the debt, the body was disinterred and the plot was made available to the next customer. The contents of the crypt were usually placed in the ossuary. A similar fate befell unkempt

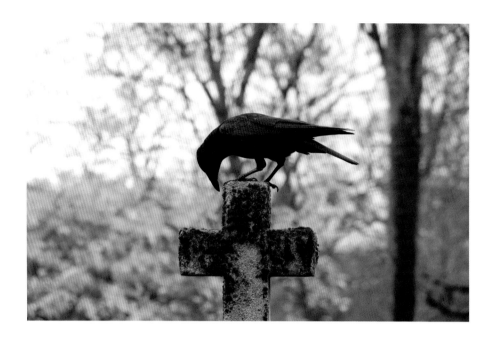

burial places, even if they were contracted *à perpétuité*. If the family or descendants did not maintain the tombs or heed warnings to make necessary repairs, crumbling structures would be removed, as would the remains. One historically minded city official lobbied to save the threatened tomb of a long-forgotten chanteuse of the Empire period whose headstone of architectural significance was fast disintegrating from the ravages of time. Luckily, as the result of a private fundraising effort, her resting place was preserved.

A century ago, Père-Lachaise was a spacious burial place in a parklike setting where graveside visitors were treated to the scent of lemon trees. Now jasmine and incense from Buddhist graves are also wafting on the air. In the Jewish section, monuments to those lost in Buchenwald and Auschwitz peer across the avenue at the centuries-old family crypts, where members of the *ancien régime* are joined together in the afterlife.

OPPOSITE PAGE: HOLOCAUST MEMORIALS.

I frequently return to the oldest area of Père-Lachaise called the Romantic section, luxuriating in the scent of rich loamy earth, velvety moss-covered mausoleums, and wet leaves. As I walk, stripes of light and dark fall across my path. Overhead, the trees form a latticed canopy. Occasionally, a brilliant beam will break through and spotlight a tomb, dust motes dancing in the filtered sunbeams. I hear the rat-a-tat of woodpeckers, the trill of the nightingale, the cooing of doves. Crows caw mournfully as they swoop low over the mausoleums. Feral cats squint into the midday sun from their crypt-top perches. Tree roots and vines aggressively embrace headstones and sometimes unseat them. A tree trunk has become one with a small chapel, at first strangling it, yet now oddly supporting it.

Of the seasons I have visited Père-Lachaise, autumn is one of the more colorful times for photographing the cemetery and strolling its paths. While surveying the panoramic imagery together, Joe shared with me his philosophy of capturing the energy of the time and place.

"Light and Depth, the photographer's equivalent of…'It's a matter of Life and Death' seemed appropriate when making pictures in Père-Lachaise." Together, Joe and I were constantly exploring the possibilities for creating balanced images. "There is a curious and perhaps unexpected side effect of the successful evocation of depth and that is the promise of emotional depth as well. Flow significantly contributes to depth, hence presenting the two themes together," Joe added. "Flow could also be thought of as 'energy,' the life force of the image. Fundamentally these are two of the primary qualities for making immersive images."

On one All Souls' Day, November 2nd, we witnessed the transformation of the cemetery. The vivid green, red, yellow, and orange foliage of thousands of trees (maple, acacia, beech, ash, lemon, chestnut), throughout the cemetery offer a sharp contrast to the somber black iron railings and gray tombs. Paris can be cold and rainy at that time of year, but bright sunlight and dazzling blue skies broke through, adding another brilliant hue to the landscape of the departed. The graves, ordinarily unkempt, were on that day highly polished and festooned with ceramic wreaths, ribbon bunting, floral garlands, votive lights, and personal offerings.

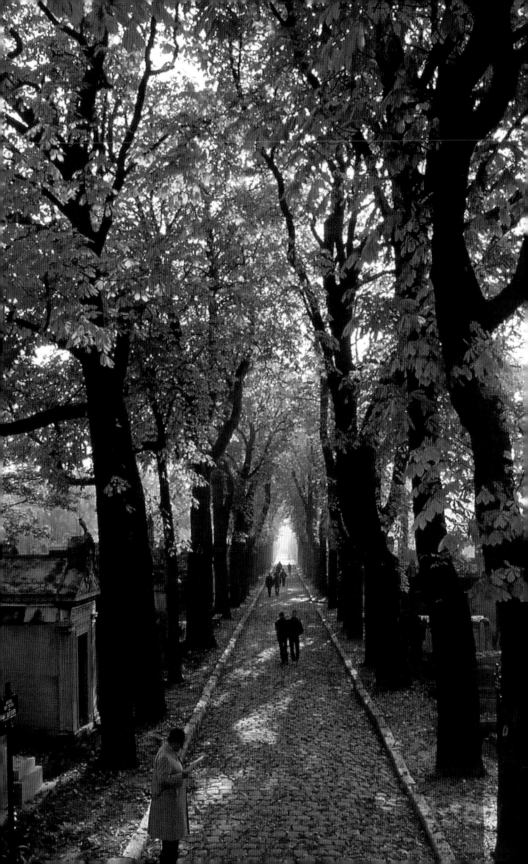

Fans and tourists gathered to pay respects at the shrines of luminaries like Edith Piaf and Frédéric Chopin, as they observed the grieving families who wept over the simple graves of loved ones. Here, too, we find startling monuments commemorating the tragedy of the Holocaust, and the communal grave at the *mur des Fédérés* (Communards' Wall); where in 1871 rebelling workers were cornered and executed after battling Parisian soldiers among the tombs. Their bodies were buried where they fell.

And so, as always at Père-Lachaise, we are confronted with the great paradox of this vast burial ground, which embraces serenity, horror, anguish, and acceptance—the grand sweep of the human experience. Day after day, year after year, the city of immortals awaits its next visitors.

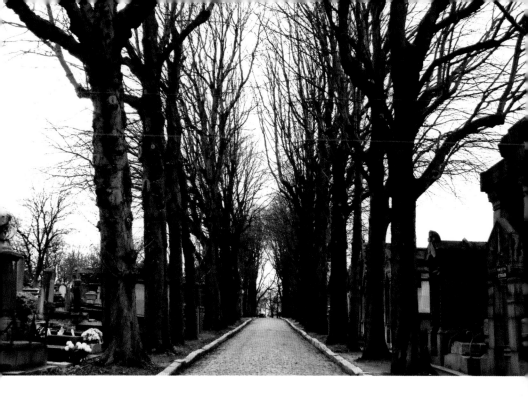

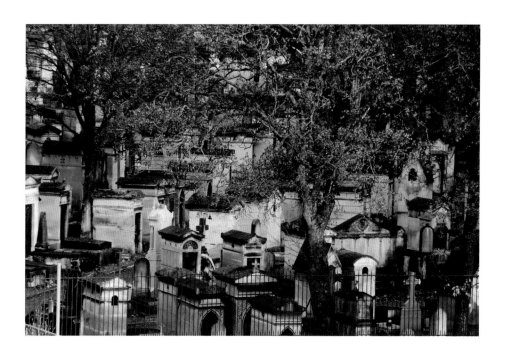

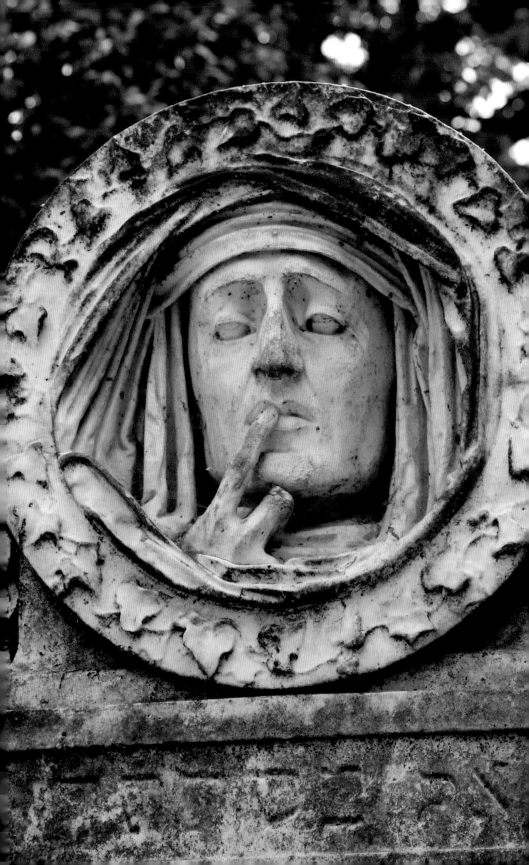

C HAPTER TWO

D ESIGNS ON ETERNITY

TO BE BURIED IN PÈRE-LACHAISE IS LIKE HAVING MAHOGANY FURNITURE.

—VICTOR HUGO

At age eight I attended the Corcoran Gallery of Art's Saturday children's classes. There I took drawing and sculpture in this grand nineteenth-century building located on Seventeenth Street across from the east wing of the White House. Designed by architect Ernest Flagg, the structure was deemed "The finest example of Beaux-Arts architecture in the United States" by legendary architect Frank Lloyd Wright. As a young girl, I marveled at the lofty atrium, with its colonnade of Doric columns; on the exterior I was mesmerized by stone griffins that kept watch along the roofline. The seeds were planted early for my fascination with architecture and design.

OPPOSITE PAGE: THE FINGER TO THE LIPS IN THIS FUNERARY SCULPTURE SIGNIFIES RESPECT AND SILENCE.

(JP)

Many architects past and present have had stellar public images. I have had the good fortune of working with such Pritzker Prize-winning Los Angeles architects as Thom Mayne and Frank Gehry. Eighteenth-century France did not lack for starchitects, and, Étienne-Louis Boullée was one example. As one of the most admired architects of the period, he was also a highly respected author and a major influence on many prominent practitioners of the day. In his view, the commission to design a cemetery crypt was one to covet. He developed a design philosophy for the funerary world that included "architecture of shadows"[2]—recesses cut into stone that cast dark shadows in the moonlight. Boullée was also a

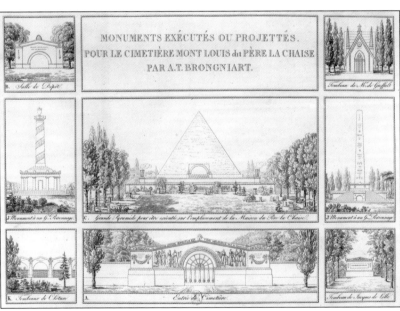

(BNF)

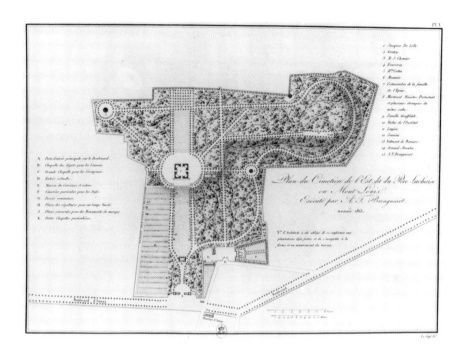

proponent of the pre-Romantic celebration of nature. This pantheistic view led to the changes in the image of a cemetery. It became a site of divinity and no longer a frightful place filled with dead bodies.

One can only imagine, then, the pride, or perhaps envy, that Boullée would have felt when one of his star pupils, Alexandre-Théodore Brongniart, won the commission to design Père-Lachaise. No previous architect or landscape designer had been assigned such a vast and unprecedented undertaking—the first proper burial area for individual gravesites to be created outside of a churchyard. Boullée's tutelage, especially in the realm of funerary design, paid off handsomely in his student's extraordinary vision for the project.

In conceiving the cemetery's design, Brongniart maintained the gardenlike setting of the former country retreat. But even though Père-Lachaise is a garden cemetery, one notices when walking its cobblestone pathways that its layout is very urban—a cityscape with winding streets and directional signs. As a landscape architect Brongniart, was the ideal man for the job. Brongniart's unique vision established Père-Lachaise as one of the most influential models

of cemetery design of its kind. It represented a radical change in attitude toward life and death through the creation of a municipal cemetery. Europe and North America have copied his pioneering style, thus Père-Lachaise's distinct character has highly influenced many renowned cemeteries around the world, including ones that I have personally visited, such as Mount Auburn Cemetery (1831) in Cambridge, Massachusetts, which is the most famous example of the rural cemetery movement in America, and has been designated a National Historic Landmark. Other examples are Highgate Cemetery (1839) in London, England; Rock Creek (1840) and Oak Hill (1848) Cemeteries in Washington, DC, and Bonaventure Cemetery (1907) in Savannah, Georgia.

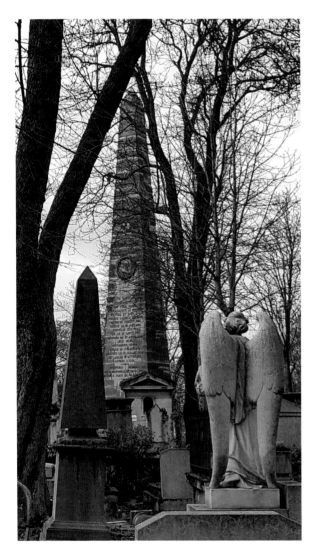

Brongniart died in 1813, so many of his grand schemes never made it off the drawing board, including his dream of a monumental pyramid as a focal point in the cemetery. Historians have been fascinated with Egyptian civilization since antiquity. In France, this obsession was highlighted by Napoléon's campaign in Egypt. Obelisks and pyramids, which appeared on buildings all over Europe, became a prominent feature throughout Père-Lachaise. Today, it is a charming mix of structures, with elegantly styled crypts next to oversized mansions of the dead encircled by rows and rows of modest headstones, creating the effect of an enchanted architectural theme park.

Brongniart's original plan was complemented over the ensuing decades by hundreds of individual tombs created by an impressive roster of designers, sculptors, and architects, many of whom were credited with creating the significant urban plan and public structures throughout Paris; some of those individuals are interred within the cemetery.

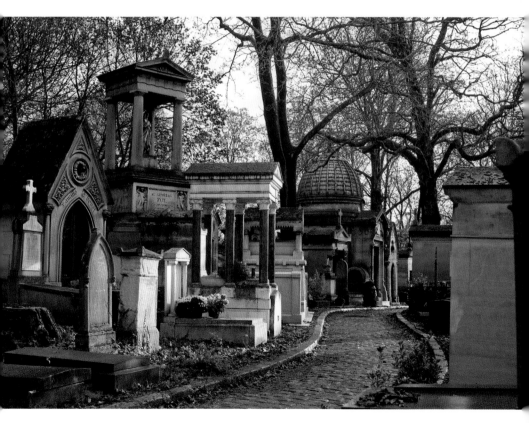

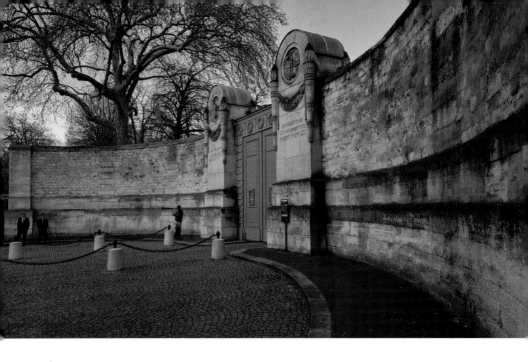

Étienne-Hippolyte Godde served as the chief architect of the City of Paris from 1813 to 1830. Known for his neoclassic designs, he succeeded Brongniart as architect of the cemetery. His design for the Boulevard de Ménilmontant entrance to Père-Lachaise consists of an elongated horseshoe-shaped driveway with a pair of tall central gates topped by two carved medallions. These bear the classic funerary symbols of the torch (life's flame) and the hourglass (time passing). Godde also designed the cemetery's mortuary-chapel and the simple hilltop Doric chapel on the exact location of the ancient Jesuit house where Father Lachaise resided (Division 55). In addition, Godde improved the overall layouts of Père-Lachaise and the cemetery at Montparnasse.

Beyond Godde's main gates and up Avenue Principale, French architect Hector Guimard designed the dove-gray marble tomb of Ernest Caillatt (Division 2), one of the only completely *art nouveau* tombs in the cemetery. His atelier's signature appears in the lower right corner near the back of the tomb. Guimard studied at the École nationale supérieure des Arts Décoratifs, where he became familiar with the theories of Eugène-Emmanuel Viollet-le-Duc, and was strongly influenced by Viollet-le-Duc's ideas about ornamental structures. A reaction to the academic art of the nineteenth century, *art nouveau* was mainly inspired by natural forms and structures, particularly the curved lines of plants and flowers. Guimard is best known for his entrances to the Metro stations throughout Paris—including the Père-Lachaise Metro Station—

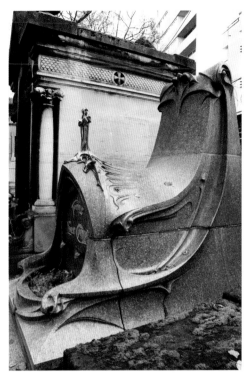

which have distinctive lettering, arched signage, and curvaceous metalwork on the railings.

Among the twentieth-century architects whose works appear in Père-Lachaise is Jean-Charles Moreux who worked with baron Robert Rothschild and vicomte Charles de Noailles as clients. He designed Colette's low, flat simple tomb of rose and black granite farther up Avenue Principale on the left in Division 4 (Tour One).

The New Louvre's architect, Louis-Tullius-Joachim Visconti, is buried off Avenue Principale in Division 4 (Tour One). The architect's own figure, sculpted in white marble, reclines atop a wide pedestal with a bas-relief of his Louvre design plan installed on its base. Visconti also created fountains throughout

Paris, including the Molière and Saint-Sulpice fountains. Trained in the atelier of Charles Percier (one of Napoléon's favorite architects along with Pierre Fontaine), Visconti designed Napoléon's crypt beneath the dome of Les Invalides, neoclassical house-style tombs in Père-Lachaise for notable families, as well as a monument for one of Napoléon's generals, Marshal Louis-Gabriel Suchet, in Division 39 off Chemin Suchet et Masséna.

Percier, along with his architectural associate Fontaine, is buried in Division 28 (Tour Two). They were largely responsible for the popularity of the Empire style of the era. One of the numerous projects Napoléon hired them to design was the grandly arcaded stretch of housing on Rue de Rivoli (the second longest street in Paris) opposite the Louvre. The Rivoli arcades represent an example of the true grandeur of Paris. The facades were officially adopted as the guideline for the entire street. Unfortunately, we won't find any of Percier and Fontaine's design contributions in the collection of masterpieces in Père-Lachaise. They are, however, interred together in the Romantic section, their site marked by a tall column topped with an urn, with the symbol of the Masons incised in a stone panel at its base.

Considered one of the first theorists of modern architecture, Viollet-le-Duc was a noted scholar, restorer of medieval buildings, central figure in the revival of Gothic architecture, and the author of a ten-volume history of French architecture. Along with his collaborator, Jean-Baptiste-Antoine Lassus, he won the commission to restore the Cathedral of Notre Dame. Viollet-le-Duc used himself as the model for St. Thomas the Apostle on the entrance façade. This was a widespread practice with which I have personal experience; my maternal ancestor Nathanael Greene, one of George Washington's generals, is featured on the east pediment of the US Capitol in Washington, DC. However, his figure sports the face of Philadelphia architect Thomas U. Walter, who designed the Capitol building.

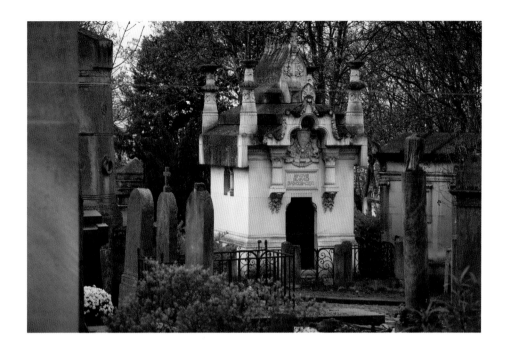

Upon completing the Notre Dame project, Viollet-le-Duc became Chief of the Bureau of Historic Monuments. That same government office now oversees the city's preservation of cemeteries. He also took commissions for various tombs and monuments, including the ornate mausoleum of the Duc de Morny in Père-Lachaise. Evidence of the architect's vast knowledge of design is displayed in this elaborate creation, which sits at the crossroad where Division 54 meets Avenue Frédéric Soulié. De Morny's burial place is a lively tribute to the language of stone and form, though with its many layered finials, it may appear to be more like an aging wedding cake.

Patrons often paired architects with sculptors when commissioning a tomb, and thus Père-Lachaise is an open-air museum of leading examples of both art and architecture of the nineteenth century. Artist David d'Angers, who is interred in a tomb of classical design in the center of Division 39 (Tour Two), produced numerous sculptures throughout Père-Lachaise. These include the equestrian monument to General Jacques-Nicolas Gobert in Division 37 along Chemin Suchet et Masséna and the bronze bust of the writer Honoré de Balzac in Division 48 (Tour Two) on Chemin Casimir Delavigne. D'Angers studied in the studio of Philippe-Laurent Roland and while in Paris worked on both the Arc de Triomphe and the exterior of the Louvre.

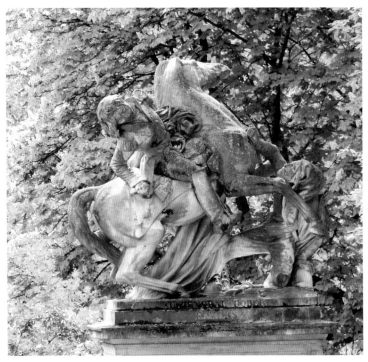

ABOVE: GENERAL JACQUES-NICOLAS GOBERT.

Sculptor Antoine Ètex has numerous examples of his work throughout Paris, including Père-Lachaise. He was commissioned to create the rectangular panel sculptures of peace and resistance on top of either side of the east facade of the Arc de Triomphe. These and other high-profile commissions established his stellar reputation. However, his most famous work is the tomb he designed for fellow artist Théodore Géricault, who is buried in Division 12 (Tour One) facing Avenue de la Chapelle, with bas reliefs of the painter's artworks, including *The Raft of the Medusa* on its base. Look for the signature of Ètex under the bronze pillow where Gericault's left arm rests. Ètex also designed the family

tomb of François-Vincent Raspail, who was jailed for his participation in the 1848 Revolution. This tomb can be found by taking Chapelle to Division 18, in the northern area off Carrefour du Grand Rond. Ètex depicts sorrow via the poignant artwork titled *Madame Raspail's Farewell to the Jailed Revolutionary;*

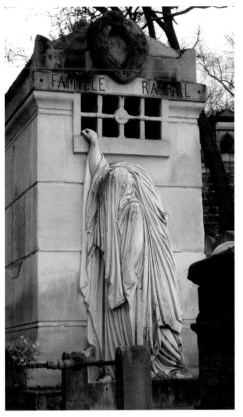

the ghost of Madame Raspail stretches her arm out from beneath her shroud toward a barred window.

The artist Eugène Delacroix, who is buried in Division 49 (Tour Two), adopted the altar tomb style for his sarcophagus of black Volvic lava with his name inscribed in gold leaf. This altar style incorporates the Doric frieze seen on the altar tomb of Lucius Cornelius Scipio Barbatus, a Roman consul in 298 B.C., and it became a very popular motif used on many nineteenth-century tombs in Père-Lachaise. The style was also employed by Léon Vaudoyer, the son of Antoine Laurent Thomas Vaudoyer, a key figure in French architecture during the Revolution.

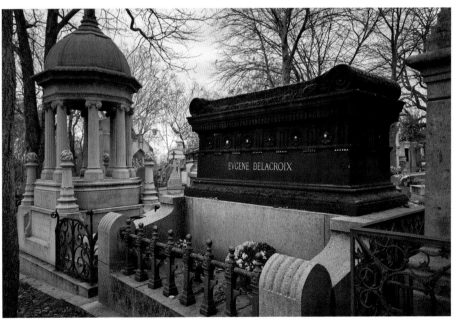

(JC)

(JC)

Léon was one of the "romantic" Beaux-Arts architects of the nineteenth century, and he won the competition with sculptor d'Angers to design the tomb of Napoléon's general, Maximilien- Sébastien Foy. It's an elegant Greek Doric monument in Division 28 facing Chemin Saint-Louis. Vaudoyer, the youngest among his fellow architects Félix Duban, Henri Labrouste, and Joseph-Louis Duc, was part of the group known in Paris as a company of romantic radicals. Their projects often elicited the disapproval of the conservative Beaux-Arts academics.

Controversy followed artists as well as architects, and the American-born sculptor Sir Jacob Epstein caused a stir with his monument to Oscar Wilde in Division 89 (Tour Three) on Avenue Carette. He carved the tomb from a twenty-ton monolith extracted from an English quarry. It presented an enormous challenge to the artist, who spent nine months carving the large stone without referring to preliminary smaller models. A nude winged sphinx, the crown on the figure's head and the hairstyle are reminiscent of the winged Assyrian bulls in the British Museum, which date to 710-705 B.C. The Wilde sculpture was one of Epstein's earliest commissions made possible through the patronage of Helen Carew, a member of Wilde's circle. The work received high praise following the press

preview, but due to its prominent male parts, was condemned as indecent. Epstein's work on the Strand in London was also criticized due to the highly sensual modeling of the nude figures. The sculpture on Wilde's tomb was at one point covered with a tarp by the French police. It was the last scandal attributed to the revered writer.

One would have to zigzag to every corner of Paris to see a comprehensive collection of the city's important sculptures and architecture reflecting periods and styles from early Roman to the present. Fortunately, the tombs in Père-Lachaise parallel this artistic growth and house all styles from the early 1800s onward.

Iconography of the Afterlife

The eternal staying power and drama of funerary monuments appealed to the architects, designers, and artists who contributed to the mesmerizing environment of Père-Lachaise. Their use of funerary symbols such as draped urns, hourglasses, bats, skulls, and mourning figures on magnificent chapels and elaborately carved crypts not only echoed the current fashions but delivered on the promise of visceral awe and wonder in the land of the dead. Having visited the cemetery close to a dozen times (totaling around 75 days), I have never ceased to discover an endless variety of carvings on tombs by many craftspeople, known and unknown.

Since the cemetery curator's office only keeps official burial records, documentation of the artists and architects who designed each tomb is left up to sleuths and historians, as well as individuals strolling the paths of the cemetery with notebook and camera in hand. Sometimes a signature can be found incised on the base of a bronze sculpture or the name of the architect's atelier can be faintly discernible etched into a corner of a mausoleum worn by the elements. It's an ongoing treasure hunt that I never cease to enjoy. As noted with the earlier examples of sculptor Ètex and architect Guimard, make sure to walk around each tomb and look to see if there is a signature.

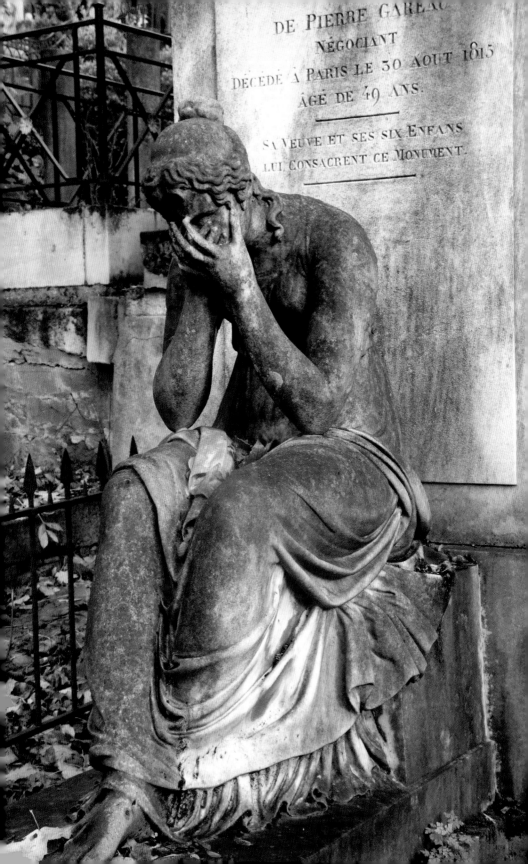

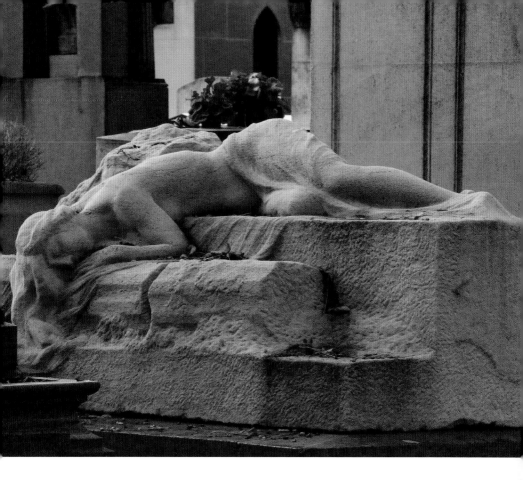

Mournful Muses

The designs in Père-Lachaise represent an encyclopedic grouping of many periods, including Gothic, Romanesque, Neoclassical, Italian Renaissance, and *art nouveau* crypts next to Egyptian revival pyramids and obelisks. Classical revival treatments as well as Doric and Corinthian columns on mausoleums also appear throughout the cemetery. These treatments incorporate the popular materials and architectural styles of the day, including stained glass, trellised iron, sculpted marble and granite, enameled figures, and various motifs such as veiled women symbolizing death and sorrow.

Nineteenth-century architects and sculptors utilized the grieving female figure as one of the most prominent characters in this theater of stone. The figure of the seated woman featured on the map and book cover is by sculptor Louis-Ernest Barrias and marks the tomb of French government architect Antoine-Gaëtan Guérinot and his wife Jeanne, located behind the large chapel in

Division 55. Statues of women often represented the seven virtues: prudence, justice, temperance, fortitude, faith, hope, and charity—powerful examples of how women embody some of the deepest qualities of the human condition. In Père-Lachaise a winged woman symbolizes hope, while charity appears as a nursing mother.

Père-Lachaise also has many scantily clad female figures. Sometimes, family members unaware of the sculptural commission must have been alarmed to arrive at the gravesite and discover a half-naked damsel in apparent erotic rapture rather than in deep mourning.

Symbols

Images of animals and objects lend unique symbolism: dogs signify fidelity, loyalty, vigilance, and watchfulness. For example, see the reclining hound at the feet of the famed lovers Héloïse and Abélard in Division 7 (Tour One). Lions and eagles mean courage (usually found on men's tombs); white doves represent beauty; owls symbolize watchfulness, wisdom, or contemplative solitude; turtles mean longevity, patience, or sloth. An image of an hourglass with or without wings represents the rapid passing of time. Wings attached to the hourglass suggest the fleetingness of life.

Bats and serpents illustrated the eerie side of eternity. Skulls or other death symbols remind the viewer that death is a part of life and unavoidable. Skulls were discouraged at one point by the City of Paris administrators who sought to replace Christian-dominated imagery of macabre sadness with what would instead reflect a more peaceful concept of a sweet rest. After all, the earliest interpretation of the word *cimetière* was "a place

where one sleeps." Winged cherubs are thus found replacing the death's head (or soul effigy). Winged figures are generally considered angels. The word *angel* comes from the Greek word *angelos*, which means "messenger." The chief duty of an angel was to carry messages from God. These figures came in many shapes, sizes, and age groups, from a cherub or putti to an adolescent to an adult.

An inverted torch, which is often found in cemeteries, indicates that the soul is immortal and that life is extinguished if its flame is out. The draped urn is another common funerary symbol. The drapery is seen as a veil between earth and heaven, while the urn is to ashes as the sarcophagus is to the body.

Plants such as the poppy flower, crowns of laurel leaves, and olive and cypress trees also adorned tombs in the Romantic period. The thorny acanthus leaf depicts the prickly journey of life and death and ultimately the final triumph of eternal life. The thistle represents earthly sorrow; ivy meant immortality and fidelity; the palm symbolizes victory, as seen on Rosa Bonheur's tomb in Division 74 (Tour One), as well as frankness and sincerity;

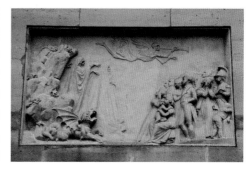

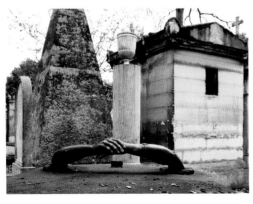

laurel motifs, often in a wreath, represent chastity, eternity, and immortality. *Pansy* comes from the French word *pensée*, meaning thought; it serves as a symbol of remembrance. Pansies, being considered to help in hearing a loved one's thoughts, were widely cultivated in the golden age of the cemetery.

Graves of accident victims or others whose lives were cut short are marked by a broken column, tree trunk, or urn. An open book is the human heart; a closed book is a completed life. A curtain or veil is a symbol of passage from one type of existence to another; a lamp is a symbol of wisdom, faithfulness, and holiness; a harp is a source of divine music; a lyre is more playful but often has a broken string in funerary use. The angelic muse on Chopin's tomb in Division 11 (Tour One) is playing a stringed instrument.

A feather signifies ascent into heaven as well as justice and authority. A flame denotes eternal life or vigilance. A rock is a powerful symbol of the divine—a large stone is accorded great power. A vacant chair can symbolize the death of a child or a young person. A toppled vase represents the end of life; a lamp

with a lit flame is the light of life; a sword denotes a member of the military.

The cross is an ancient symbol predating Christianity; it may represent the division between heaven and earth. The two most common in Père-Lachaise are the Greek cross, which resembles a plus sign; and the Latin cross, which looks like the letter "T."

Words may accompany symbols. In the first half of the nineteenth century, epitaphs displayed the feelings of the bereaved in lengthy sentimental poems filled with personal details; examples of such epitaphs can be seen on the tombs of Guillaume Apollinaire in Division 86 (Tour Three) and Fernand Arbelot in Division 11 (Tour One). By the second half of the century, however, only brief regrets appeared, painted on ceramic plaques. Some tombs' carvings immortalize unique aspects of the departed's character or a somewhat quirky sense of remembrance. For instance, a leather-capped and goggled chap behind a car's steering wheel commemorates Léon Théry, a French race car driver.

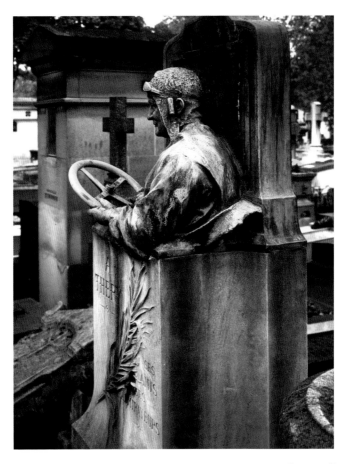

Romantic tombs commemorate undying love—lovers' arms stretched out to each other, or gazing into a partner's face for eternity —as seen in the tomb of Fernand Arbelot in Division 11 (Tour One) on the bottom panel of the map..

Throughout several centuries, doorways were often used as a metaphor for movement from life to death, and other times as an entryway into a family crypt. A sculpture by Paul-Albert Bartholomé, *Aux Morts*, in Division 4 (Tour One) is the largest example of a doorway motif in the cemetery. It shows figures gathered at a symbolic gateway to the afterlife. The epitaph on *Aux Morts* reads "Of those who inhabited the world of the shadow and the dead, the light shines on them."

It became apparent after seeing clusters of famous people buried in close proximity to one another that many artists and architects wished to be buried near their compatriots, including the writers Honoré de Balzac and Gérard de Nerval in Divisions 48 and 49 respectively (Tour Two) and architects Percier and Fontaine in Division 28 (Tour Two). A friend of rock star Jim Morrison remarked that he thought Jim would have liked being laid to rest in the company of Chopin. In fact, he is buried only two divisions away from the composer. I can readily imagine these creative spirits communing. The striking originality of each gravesite and the stories behind their creation confirms that Père-Lachaise is indeed an unprecedented salon of the afterlife.

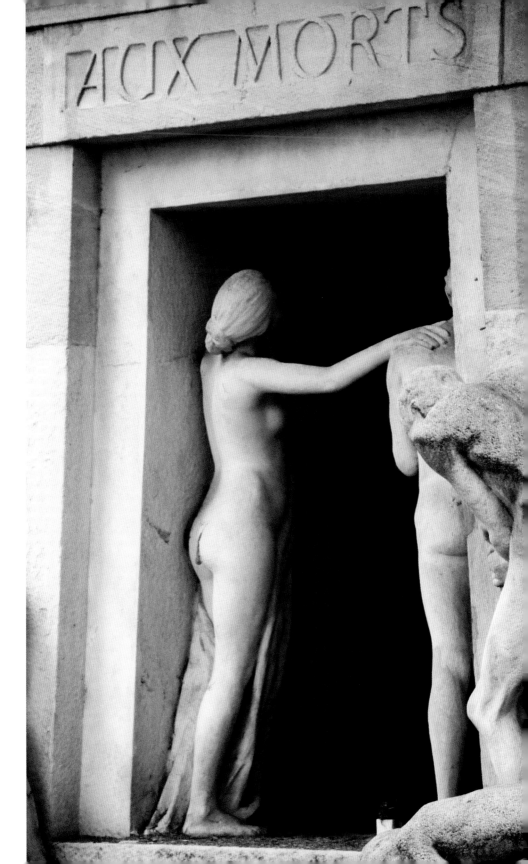

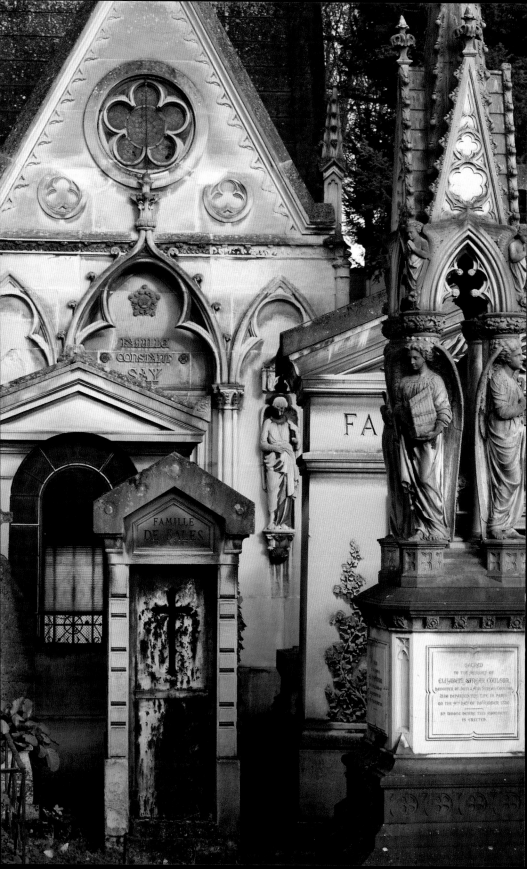

CHAPTER THREE

CONVERSATIONS WITH THE IMMORTALS

Many visitors to the cemetery come bearing mementoes to leave at the gravesites—flowers, photos, a personal item, letters, small pebbles. I have even seen Paris Metro tickets (allowing for travel to the past or present?). Beside the tombs of writers, a new tradition has recently sprung up—a small jar filled with pens and pencils, both as a symbol for the scribe interred as well as, I suspect, a ready implement should one want to jot down a thought to leave behind. A yearning to speak directly with the departed is what inspired me to have these encounters.

Initially, I longed to ask Oscar Wilde why he didn't flee England for France, thus avoiding a horrendous trial and his subsequent sentencing to hard labor in prison for his homosexuality. So, I decided to have that conversation and more.

In this chapter, I speak with several cultural icons about their triumphs and failures, as well as any wisdom they wanted to share with those above ground. They appear in the order one might encounter them on a tour: Sidonie-Gabrielle Colette, Frédéric Chopin, and James "Jim" Morrison in Tour One; Honoré de Balzac in Tour Two; and Oscar Wilde, Edith Piaf, Amedeo Modigliani, and Isadora Duncan in Tour Three.

In my career, I have collaborated with and represented many artists and performers, and I have even written their obituaries while I was the editor of an arts magazine. I identified with their struggle, survival, joy, and redemption. These are the traits that allowed us to open up to each other, and I believe it is why the immortals granted me access for the interviews.

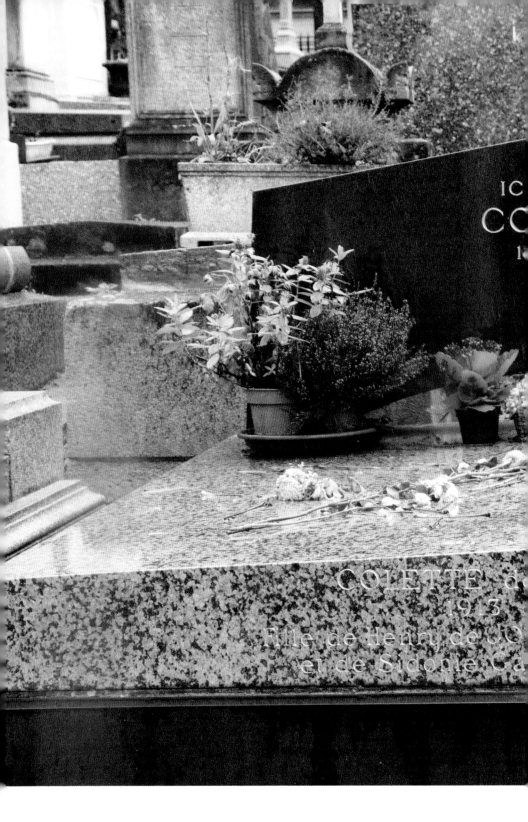

Conversation with Sidonie-Gabrielle Colette
Division 4, Tour One

My sister Kathleen introduced me to the works of Colette when I was about eleven. Kathleen had very sophisticated tastes for a thirteen-year-old and told me that Colette was the leading literary figure in France and had authored fifty-odd novels, some of which were made into movies, including *Gigi*, directed by Vincent Minnelli, starring Maurice Chevalier and Leslie Caron. It was racy stuff for young girls.

Colette's stories depict intense physical pleasures and complexities of relationships, the psychology of women and, as Kathy warned, a fair share of the author's own carnal exploits. I found Colette's sensuality also apparent in her descriptions of nature and animals, domestic or running wild, the fragrances of flowers, and the beauty of the senses. Her language is so vivid that I believe her pages are meant to be inhaled.

Standing at the foot of her low, pink and black granite tomb—wide, like her bed, or "raft" as she called it, since arthritis kept her bedridden, I can envision her hair, wild and frizzy, and her eyes encircled in heavy kohl. Her scarlet lips break into a wide smile as I pose my first question.

Carolyn Campbell: Since you lived to be eighty-one, it would be almost impossible to cover all you did during the Belle Époque through the German occupation and beyond, but I would like to hear about the key stages in your life. What guided you?

Sidonie-Gabrielle Colette: *My earliest influences were my parents. My mother, Sido, in particular. I recall when she was asked by the church to cut some flowers for a memorial service. She refused, saying why should she give flowers to a dead person? Instead she gave the flowers to a child to play with. She defied*

convention. She gave me permission to do what I felt was right, not what was expected of me. She also gave me my love of nature and animals, which led to my lifelong passion for cats and my beloved French bulldogs.

CC: I, too, am grateful that my family loved the outdoors and nature. We lived by the water and were allowed to roam freely.

Though I see how you were independent, there seemed a time when you allowed your husband Henri Gauthier-Villars, known as Willy, to take credit for your writing. How and why did you allow him to take advantage of you?

SGC: *In the beginning it was passivity on my part. He locked me in my room to write. He exploited me. I had no place to go. I was very young. I eventually began to love writing, and Willy as an editor taught me a great deal, so there was something good that came of it.*

CC: What were the significant challenges you faced as a woman, and how did you see them change over the decades as you grew in prominence as a writer? Were you able to make a living?

SGC: *I broke free from the constraints of my thirteen-year marriage to Willy, which had been arranged by my parents; they felt a wealthy man was a good thing. But I was only successful to a point. I found I had another option when I met Missy (the wealthy noblewoman Marquise de Morny). She encouraged me in anything I wanted to do, so I became a music hall dancer, stage actress, fashion critic, and acrobat. I regret that I broke her heart. After I left her I was able to support myself with my different creative ventures. I even had my own cosmetics line.*

CC: What subjects inspired you? What was your process?

SGC: *I never tired of reading Balzac and Proust. Many of my novels were thinly disguised autobiographies. Love, licit and illicit. Women and their problems with love. I wrote every day. It fed my creative momentum.*

CC: I'm sure my fearlessness in taking on numerous creative ventures is rooted in my parents' confidence in my abilities. Where did your momentum originally stem from?

SGC: *To be courageous. To risk. The love of my parents gave me enormous self-confidence. I knew who I was. My advice to anyone: be true to oneself.*

CC: Based on your self-declared individualistic philosophy, what advice would you give to those choosing a creative pursuit?

SGC: *I once advised a young writer, "Look for a long time at what pleases you, and longer still at what pains you." I tapped into all of life's paradoxes as fodder for my work.*

CC: Can you expand on that?

SGC: *I always watched, listened, observed. I wrote what I knew about. My daily life; l'amour. "Love…love has never been a question of age. I shall never be old enough to forget love, and to stop thinking about it, and talking about it."*

CC: What were some of your activities that scandalized the public?

SGC: *Appearing on stage as an actress, and an acrobat, half naked. Having a very public lesbian love affair.*

CC: At your funeral, the minister of National Education, who spoke on behalf of the French government, called you "pagan, sensuous, Dionysiac." Do you think his description was accurate?

SCG: *Well it surely could have been, my having had three husbands, and I was known or suspected to be bisexual, because of my six-year relationship with Missy, as well as an affair with Josephine Baker. I even seduced my sixteen-year-old stepson. So, yes, I was a sexual revolutionary, but I had a conservative side that seems to have been overlooked by my biographers.*

I was a Parisienne, but I was also a provincial Frenchwoman from Burgundy. I loved going back there. The conventions of provincialism were instilled in me and, though I rebelled against them, they were still a part of me. I was never political nor did I belong to any movement. I lived life on my own terms. I was a cultural anarchist of my own making.

CC: Your two divorces certainly had their consequences when it came to your burial rites.

SGC: *Oui; tant pis. My third husband, Maurice Goudeket, and my daughter Colette de Jouvenel from my second marriage, should have known that the cardinal would deny me a religious service. My lifestyle hardly mirrored the Catholic church's beliefs. Thanks to the separation of church and state, I got even. Since the French government awarded me the rank of Grand Officer of the Legion of Honor just after my eightieth birthday, I was entitled to full military honors at death.*

CC: For all your high-profile theatrics as a performing artist and your illustrious career as a writer, your actual graveside burial was very low-key.

SGC: *Mais non! I was the first Frenchwoman to be honored with a state funeral, the highest posthumous tribute that could be paid a French citizen. The theatrics were reserved for when my coffin lay in state on a raised, funeral catafalque in the cour d'honneur of the Palais-Royal. There was a hedge of floral offerings from friends, civic, and cultural groups, in which pale blue and dark blue gladioli, my favorite color, were predominant, of course. Yet, I preferred for my actual burial to be in absolute privacy in Père-Lachaise.*

CC: I heard that many admirers and fellow artists came by the Palais-Royal when you lay in state to pay their respects.

SGC: *Many of my dear friends and French notables were among the thousands who came. The August heat was stifling, but fortunately, a light breeze came up that morning and picked up the edges of the French tricolor, which draped my catafalque. Marlene Dietrich assured my dear friend Jean Cocteau (who was sick and couldn't attend), that "the flag seemed to live and breathe as it enveloped the coffin." I was very touched by Cocteau's later writing in a Paris paper about what he sensed was the atmosphere of my private burial at Père-Lachaise: "It was not a question of funeral rites, but rather of gardeners digging, of the passing from one reign to another, of earth and flesh in collaboration."*

As we began to bring our visit to a close, Colette remarked that minutes before she died of cardiac arrest, a flock of swallows flew chattering past the open windows of her Rue de Beujolais apartment that overlooked the gardens of the Palais-Royal. She called out for her husband, "Regarde, Maurice, regarde." Those were her last words. To the end she followed her own advice: always listen and watch.

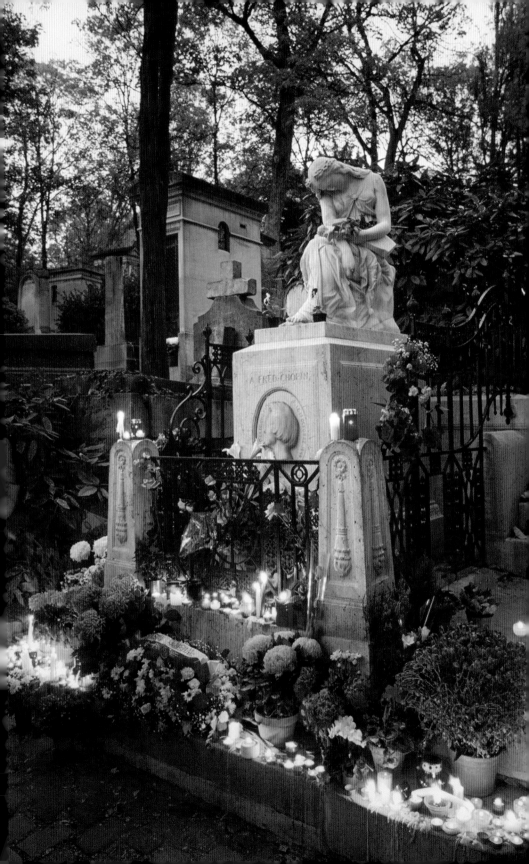

Conversation with Frédéric Chopin
Division ii, Tour One

My antidote to being stuck in Los Angeles traffic is playing CDs of Chopin. He was a musical genius at the piano, and his etudes, nocturnes, mazurkas, and polonaises transport me from the crowded freeway to the salons of Paris. Many say he played with classical restraint blended with romantic feeling. Chopin said that the Polish word *żal* (bittersweet melancholy) best described much of his music. Some felt it paradoxically could mean anger, even rage, which was also part of his musical vocabulary. I agree with German composer Robert Schumann, who said that Chopin's playing was like "cannons buried in flowers." Chopin's close friend, the artist Eugène Delacroix, called his music "nourishment for the soul."

Standing in front of Chopin's gravesite for the first time on All Souls' Day, votive lights flickering and the tomb swathed in garlands of flowers, I gazed at his sculpted profile. It's ironic that the artist Auguste Clésinger, who created the portrait, was the reason for an irreparable rift in Chopin's relationship with his long-time love George Sand. Sand's daughter Solange married Clésinger even though Chopin warned, and Sand later discovered, that he was a con man and a brute. For all the passion and success in his career, loss and longing filled Chopin's private life.

I admire his music but am saddened by his seemingly lifelong suffering. I look forward to discussing how he dealt with it.

Carolyn Campbell: I understand that you arrived in Paris from your native country, Poland, as a young man and never returned. Did you have any regrets, and what kept you in Paris?

Frédéric Chopin: *Well, I was originally heading to Italy, but there was unrest there, so I went to Paris. Though I consider Paris élan vital, I always longed for Poland, and my mazurkas, for one, reflect my deep ties to my homeland. Sometimes, I would be overwhelmed with feelings of aloneness and depression. I would come home and weep out an adagio on the piano. I stayed because of friends from Warsaw; I was earning a good living, plus, of course, the women.*

CC: I read that you were a real charmer. Care to elaborate?

FC: *My lover of eight years was the Baroness Amantine Lucile Aurore Dupin, who took to calling herself George Sand. Our breakup was not a pleasant one. And there was my muse, the Countess Delfina Potocka. Later in life I was supported by an admirer, Jane Stirling.*

CC: It's also been written that Sand had a voracious sexual appetite. Since you remained together for many years it seems that intimacy appealed to you. Was there a sensual connection with your music?

FC: *Honestly, I feel I created my best works when celibate. Sand and I hadn't had sex during our last years together.*

CC: Unfortunately, all of George Sand's letters were destroyed and many of your letters lost, so material is scarce for constructing an accurate biography about your personal life.

FC: *Historians can never really confirm what happened, can they?*

CC: You remain a mystery in many ways. I understand that your friend, the composer Franz Lizst, would introduce you as "a man who comes from another planet."

FC: *As young men, Franz and I lived in heady times in Paris. I was twenty, he was twenty-one, and Verdi and Wagner were only seventeen. We must have seemed like aliens to the old lions like Rossini, Cherubini, and Meyerbeer, all in their eighties. I believe Franz was referring to my musical aesthetic, but I do admit to being somewhat otherworldly in some respects. I was very superstitious. I believed that the numbers seven and thirteen were lucky, I would always enter*

a new place with my right foot first, and I would never start a new enterprise on a Monday or a Friday.

CC: I totally relate to that. I won't sign a contract during Mercury retrograde, and four is my lucky number. Some people found you aloof but, I suspect, it may have had to do with your serious health problems. Did that affect your overall attitude as well as your performing?

FC: *Regrettably misdiagnosed by an assortment of doctors, I suffered for many years with consumption. I preferred performing in salons rather than concert halls, as it was less demanding and, quite frankly, that was the ideal venue for my music. And, yes, I admit that many times playing even the simplest of programs was a struggle for me, and social situations were a particular strain. But others will confirm that, when able, I would happily perform spontaneous comedy sketches after a dinner party to the delight of my friends and patrons.*

CC: You doing a stand-up routine is a surprise! It was also hard to believe that you performed only thirty times publicly in Paris. However, you became one of the most admired musicians of your era during your short lifetime. With the news of your death at thirty-nine, several articles were published; writer and drama critic Jules Janin noted in *Débats*, "He was music itself, inspiration itself; he hardly touched the earth we walk on, his talent resembled a dream!" Janin also paid homage to your sensual side, saying, "of all the artists of our day, it was Chopin who most of all struck the soul and spirit of women."

You should know that your music inspired not only those in the classical world, but Jimmy Page, the founder and lead guitarist of the rock group Led Zeppelin chose to play your Prelude in E minor, Op. 28, No. 4, at a benefit concert in New York. The band raised a lot of money that night.

FC: *Oh, money. I regret not leaving any money when I died, but a committee of my friends, led by Jane Stirling, got together and planned to have a monument built in Père-Lachaise. Ironically, Clésinger, who made my death mask and took a cast of my left hand, was awarded the commission.*

CC: I've seen drawings of you, and the portrait medallion in marble on your tomb is a good likeness. A figure of a girl representing the genius of music bows in grief, holding a lyre with broken strings pointing toward your profile. I think the inclusion of the lyre may hark back to George Sand when she

realized that she was in love with you. It's been said that at that time, she stopped working on her current novel and started *The Spirit of the Lyre*, which she saw as a symbol for you.

FC: *At the end, I finally succumbed to the ravages of what is now called tuberculosis. Even, in my weakened state, I had the pleasure of listening to my dear Delfina sing melodies of Bellini at my bedside; or maybe it was Stadella's "Hymn to the Virgin." See, I can't even verify what happened. I do recall that though I hadn't had a religious practice for many years, a Catholic priest performed the last rites, and I received the sacrament.*

CC: It may or may not have been your wish, but the arrangements necessary to have Mozart's Requiem sung at your funeral delayed the service for two weeks. Friends had to wrangle extraordinary permission to allow the female singers, not usually permitted to perform in the church, into the Madeleine.

FC: *It was an honor to have the Requiem sung at my service. Mozart was my favorite musician, along with Johann Sebastian Bach, who was my childhood inspiration. I was also deeply touched that my pallbearers included the music publisher and piano builder Camille Pleyel and my dear friend, Eugène Delacroix.*

CC: I understand that so many flowers arrived at your crypt that the Franz Liszt was moved to say that you "seemed to sleep in a rose garden." Three thousand mourners filled the church, while a mass of people gathered outside and on the adjoining streets. Traffic came to a standstill. The great portal of the Madeleine was draped in black cloth, the initials F.C. shining in silver on the cloth.

FC: *The elaborate trappings seem well suited to the Romantic movement of which I was a part. The champions of Romanticism proclaimed music to be the apex of the arts and the musician the quintessential artist. Delacroix said he saw me in this light and considered me a pure artist. I certainly seem to have benefitted from this nineteenth-century aesthetic shift; only half a century after Mozart was laid in a pauper's grave, I had a funeral worthy of a great statesman.*

CC: As they carried your coffin up the aisle, the orchestra played the Marche Funèbre from your Sonata No. 2 as well as your B minor and C minor Preludes.

When Mozart's Requiem began, the curtain was partially drawn aside, leaving the male singers visible but the two women concealed; they could be heard but not seen. Following the service at the Madeleine, everyone made the long trip out to the cemetery, but you didn't want a eulogy.

FC: *Yes, mass was celebrated in the chapel in Père-Lachaise, but it was my request that there be no speeches at my graveside. The mourners just threw flowers. An urn of Polish soil was sprinkled over my grave. My sister's request to have my heart removed and taken back to my native Poland was granted. She found a lock of Sand's hair among my things, and now it, along with my heart, rests in the pillar of the Church of the Holy Cross in Warsaw.*

CC: It was Théophile Gautier who summed up a report of your funeral: "rest in peace, beautiful soul, noble artist! Immortality has begun for you, and you know better than we the great thoughts and high aspirations are found after your sad life down here!"

FC: *Though there may have been many contradictions about my life, hopefully, there is no doubt that even with the emotional ups and downs and my recurrent illnesses, I was entirely devoted to the creation of music and the pleasure it gave to my audiences.*

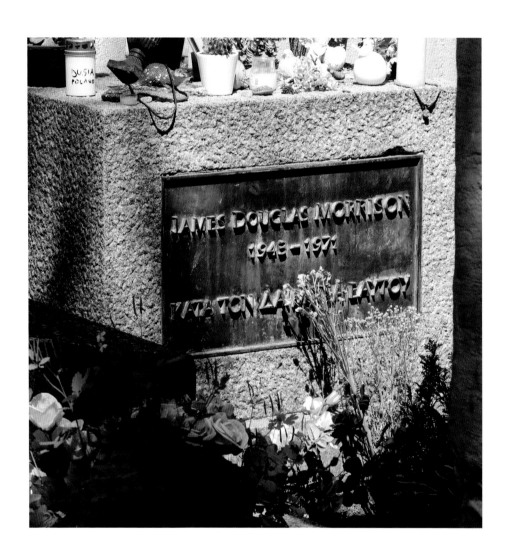

CONVERSATION WITH
JAMES "JIM" MORRISON
DIVISION 6, TOUR ONE

As a member of the baby boom generation, I personally related to this particular gravesite more than all the others in Pére-Lachaise. Jim Morrison personified an era that I was part of: the Vietnam War, the Civil Rights Movement, sexual liberation, Pop art, the drug culture, and the loss of so many creative icons of the 1960s. Although I never saw The Doors live in concert, I certainly danced to their hit "Light My Fire" played by cover bands in nightclubs and bought their albums. My conversation with Morrison at his graveside brought up memories that I hadn't connected with in decades.

Carolyn Campbell: I spoke with your friend and Doors keyboard player Ray Manzarek in 1982 when I got back to the US after my first visit to your grave. I was told so many wild anecdotes about your death and burial that I had to find out from a reliable source what really happened.

Jim Morrison: *Was he able to give you the answers you wanted?*

CC: He suggested I keep a sense of balance about the sensationalized stories I had heard and would continue to encounter. He was right. More important is what he shared about who you were as an artist.

JM: *Ray and I met at UCLA in the film department. We were drawn to cinema. It combined all the arts: theater, photography, music, acting, writing—everything.*

CC: You two formed the group The Doors, correct? How did you come up with the name?

JM: *We took the band's name from Aldous Huxley's book* The Doors of Perception. *Huxley took it from William Blake, who wrote: "If the doors of perception were cleansed, everything would appear to man as it is: infinite."*

CC: I live in West Hollywood right around the corner from the Santa Monica Boulevard studio where the group recorded. There's a bronze plaque on the Alta Cienega Motel across the street, where supposedly you did some of your legendary partying. I'd like to hear from you about the intellectual pursuits that counter your Lizard King image. History seems to have missed exploring the man who is behind those extraordinary lyrics.

JM: *Primarily, I considered myself a writer, and I read a lot, Greek and Roman classics, French Symbolists, German Romantics, modern novels by Hemingway, Faulkner, Fitzgerald, and existentialists such as Camus, Sartre, and Genet. However, these interests were overshadowed by my drinking. My friends, family, and sometimes my fans, unfortunately, were the unintended victims of my alcohol excesses. I see that visitors to my grave leave joints and bottles of booze. I hope they got a bit more out of my message than that.*

CC: For me there is no doubt of your legacy as a poet and musician. The Doors albums are some of the highest selling in history. The group got a star on the Hollywood Walk of Fame and was awarded a Grammy for Lifetime Achievement. Ray Manzarek told me that you were the "American Dionysus, you danced the dance of the Shaman—the dance of death— preached human possibility—breaking through to the other side—you danced into madness but left us a message: that you dared to risk living on the edge but you going over that edge should be a warning to us."

JM: *My moving to Paris in 1971 with my longtime girlfriend Pamela Courson was to take a break from the pressures of fame. I just wanted some R & R after making our last album.*

CC: Your band manager Bill Siddons said in an interview that you were being worshipped into a box, and you were really victimized by it.

JM: *Well, I created a monster that got out of control and it turned on me. Like my alter ego, Steppenwolf. I think Steppenwolf's creator, Hermann Hesse, summed it up best: "It happened to him—as it does to all; what he strove for with the deepest and most stubborn instinct of his being fell to his lot, but more than is good for men. In the beginning his dream and his happiness, in the end it was his bitter fate."*

CC: Too many wildly talented people met a similar fate in that abuse-riddled era. At about your age, I found myself staring into the casket of one of my dearest friends who had accidentally overdosed. There were so many unnecessary losses. Ray said he'd gladly trade back decades of time spent doing other things if you could have lived. He said you'd be making music, poetry, doing theater, and creating films together. Didn't we all think we were immortal in our twenties?

JM: *I was already having signs of some underlying health issues in Paris: On top of my heavy smoking and drinking, I became easily winded walking up a simple flight of stairs only a few days before I died, I had several episodes of severe hiccup and coughing spasms that wracked my chest. One night when Pam was asleep, I snorted far too much of her heroin stash. And from there…*

CC: I am so sorry, but it's what alcoholics and addicts do, Jim. I don't feel we will ever know the exact circumstances of your death in your apartment at 17 rue Beautreillis, but I don't think it really matters at this point.

JM: *Pamela and I loved Paris. I was writing a lot, enjoying the anonymity, and hanging out with wonderful people, including old friends like Alain Ronay, who also studied film at UCLA when I was there. I had almost stopped drinking. After I died, it took three days for all the necessary reports to be filed and formalities to be honored before my body could be released for burial and funeral arrangements made. There was no autopsy. Everyone came through and supported Pamela in all of this.*

CC: Did you leave any requests as far as your service or tomb?

JM: *No, but Pamela and Alain found a place in Pére-Lachaise hidden between two tall tombs, which they wanted so as to create privacy. There was no headstone. I like the fact that I am buried in the same cemetery as Chopin and Balzac.*

CC: I was given a description of that day: At 9:00 A.M. a small van came to pick up your blond oak coffin for the short drive to the cemetery. Bill, Alain, your personal assistant Robin Wertle, and filmmaker Agnès Varda were at the graveside. The entire ceremony took eight minutes.

JM: *Bill Siddons and Pamela had designed a tombstone with an inscription and sent money to someone in Paris, but it never was made. When Pamela died*

three years later, her parents asked that her ashes be spread on my grave, but sadly that never happened either. Before 1981, when Croatian sculptor Mladen Mikulin placed a lifelike bust of me on my grave, which helped identify the site, fans provided bizarre graffiti on surrounding tombs guiding mourners to my hard-to-find plot, but some people weren't happy about that.

CC: Yes, I saw a lot of that firsthand. As a last futile attempt to keep down the defacements, cemetery officials have installed metal barricades to discourage vandalism and supposedly guard dogs are posted throughout the cemetery to deter after-hours interlopers. An estimated 10,000 people showed up on July 3, 2001, for the thirtieth anniversary of your death and were asked to file in by small groups to keep things from getting out of hand. In 1988, unfortunately, two reckless fans on a motorcycle stole the marble bust. Your family later installed a bronze plaque, which is now mounted on your headstone with words in Greek that translate as "True to his own spirit."

JM: *I see so many young people coming to visit. None of them could have been born while The Doors were performing.*

CC: I think they may see you as a symbol of their own restlessness. They idolize musicians who have died young and tragically; Janis Joplin, Jimi Hendrix, Brian Jones, Kurt Cobain, and Amy Winehouse. There's a collective anxiety in witnessing how frail life is and the malaise of society. When I asked Ray how he would envision an appropriate burial tribute to you, he said, "I would just like to give these young people a clue about what Jim was preaching. I only regret that some of Jim's own words were not inscribed on the headstone. I would have liked to have seen his lyric, 'O great one, grant us one more hour to perform our art and perfect our dreams.'"

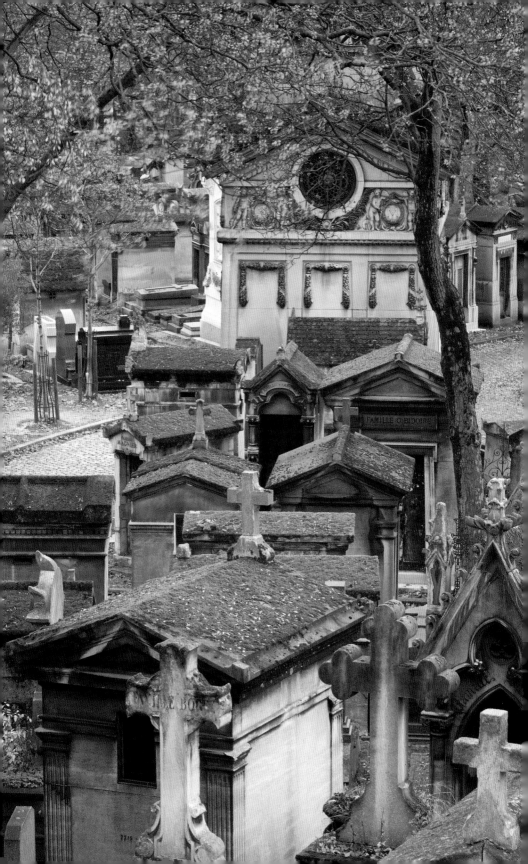

Conversation with Honoré de Balzac

Division 48, Tour Two

My first encounter with Honoré de Balzac was not on the page but standing at the foot of a towering bronze sculpture of the writer created by the artist Auguste Rodin. That imposing figure was as unforgettable as the author's masterpiece, *La Comédie Humaine*, a collection of 100 linked stories and novels. As a budding Francophile, I later spent hours devouring his novels. Through the lives of more than 2,000 characters, he told the story of nineteenth-century France—in essence, the history of modernity. In his last novel, *The Wrong Side of Paris*, his portrayal of greed, financial fear, and social alienation is as universal as if it had been written today. In the late 1990s, the French actor Gérard Depardieu brought the author to life on the big screen. The actor paid just homage to Balzac's overindulgences and obsessive work pace that led to his early death.

At one of the highest points in the cemetery, I arrive at Balzac's tomb, which features an imposing bronze bust along with a bronze book and a writer's quill pen at its base.

Carolyn Campbell: Monsieur Balzac, why did you call Paris your "dear hell?"

Honoré de Balzac: *It represented insults and ingratitude. Friends once had to talk me out of jumping into the Seine. Though I loved Paris, it also terrified me. Paris meant creditors. It's no mistake that the continuing thread in my novels is how money emerges as the single source of power in French society. You could say that money is one of the major characters in my novels.*

CC: Did you always know you wanted to be a writer?

HB: *I was a voracious reader and sought a career in literature. At the beginning, to keep from starving, I wrote pulp novels, or potboilers, as they were called then.*

Another strategy for creating income during those lean times was publishing, and then printing, and that's when my lifelong struggle with debt began.

CC: I understand that this wasn't the first financial disaster in your life.

HB: *No, just when I thought I could retire some debts when my father died, my inheritance went to my mother, to whom I owed 50,000 francs.*

CC: Your relationship with your mother was always a bit strained. Why?

HB: *I was neglected as a child. I spent six years in a horrendous boarding school as a young boy and only saw my mother twice. She was cold and moody and preoccupied with mysticism when what I wanted and needed was her love. However, we did share a fascination with séances.*

CC: That painful relationship didn't seem to affect your ability to have many affairs, even with different women simultaneously.

HB: *Yes, I enjoyed the company of a wide variety of women, and sometimes those encounters did overlap. The market for novels was mostly with women, and so you could say I was cultivating my audience. The love of my life was married. She was a Polish countess and her name was Eve Hańska. We carried out our affair for many years solely through letters. I wrote her once, "Only artists are worthy of women, having something of the women in themselves."*

CC: You not only loved upper-class women but the trappings of the good life as well.

HB: *I was attracted to aristocrats, so much so that I added the "de" to my name. As impoverished as I was, I did acquire some fine amenities, my collection of walking sticks for one. Some were made of gold and rhinoceros horn with knobs encrusted with turquoise or carnelian—I believe they had magical properties, all the better to become invisible and observe the characters for my novels.*

CC: Your lifestyle sometimes seems an exaggerated version of your novels. Your workaholic pace, writing twelve to sixteen hours daily, fueled by your addiction to coffee, brought on spells of depression and physical neglect that set the stage for your eventual demise. The autopsy showed that you were ravaged with gangrene, peritonitis, a weak heart, lung inflammation, and dropsical swelling.

HB: *Yes, I identify with Rastignac, a self-modeled young man of noble (albeit*

poor) extraction in Le Père Goriot. *I even cried out on my deathbed, "Send for Bianchon (the famous doctor of* La Comédie Humaine*). He'll save me!"*

CC: Your problems with money and debt seem as voracious a disease as your other ailments. The entire world seems to be suffering from it. My father had a fear of financial insecurity and held down several jobs at one point, though our family never suffered. Yet, I picked up on that fear and struggled with overworking myself and always worried about money—needlessly, really. As a writer, did you find that all the stress was worth it?

HB: *Even with my frequent relapses, I lived a full life. Five months before the end of my fifty-one years, I married my longtime mistress, Eve. As I wrote, "I had neither a happy childhood nor a fruitful springtime; I shall have the brightest of summers and the most mellow of autumns."*

CC: You lay in state for two days, but as the greatest novelist of the century you were not entitled to any official pomp, or so judged the *curé* of Sainte Philippe-du-Roi.

HB: *There was no insignia on the black drapery on my coffin, no muffled drums, uniforms, or embroidered tunics. But at eleven o'clock, all those who admired my genius gathered around the Church and the Chapelle Saint-Nicholas. The critic Barbey d'Aurevilly wrote on the same day, "This death is an intellectual disaster to which only the loss of Byron can be compared." The government was represented by the Minister of the Interior, Pierre Jules Baroche who, with my dear friends Victor Hugo, Alexandre Dumas, and Francis Wey, held the tasseled uprights of my funerary canopy on its way from the chapel to the church.*

CC: The funeral procession moved with an interminable slowness along the whole length of the Boulevard de Ménilmontant to Père-Lachaise. Dumas and Hugo followed on foot. At the cemetery, Hugo, who narrowly escaped being crushed between the hearse and a monument, delivered an oration: "Great men lay their own foundations, but it is for posterity to erect the statue....On one and the same day he enters glory and the tomb."

I bid adieu and leave him to rest on that hillside where Rastignac uttered his challenge to Paris, "Now it is between the two of us!"

CONVERSATION WITH OSCAR WILDE
DIVISION 89, TOUR THREE

The actor Vincent Price brought Oscar Wilde to life for me in his one-man play *Diversions and Delights* in 1977 at Ford's Theater in Washington, DC. Price re-created Wilde's 1899 two-act public talk in Paris detailing his life, his works, and his love for Lord Alfred Douglas. Wilde performed for some much-needed money a year before he died. It was eerily authentic, with Price repeatedly stepping offstage, imitating Wilde drinking absinthe to soothe a painful ear infection. Eventually Price, in the character of Wilde, brought the bottle on stage and was soused by the time he took his final bow.

My continuing admiration for Wilde was rewarded decades later in Los Angeles when I discovered UCLA's William Andrews Clark Memorial Library and its Oscar Wilde Collection, the finest public collection in the world. At an academic symposium on Wilde and the Culture of the Fin de Siècle at the Clark, I had the great fortune of meeting Wilde's grandson and scholar, Merlin Holland. Here in Père-Lachaise, I finally engage Wilde himself in conversation.

Carolyn Campbell: Mr. Wilde, your tomb is one of the most visited in Père-Lachaise. Why do you think that is?

Oscar Wilde: *Well, I am very flattered to see the throngs of handsome young men; I would like to think it's because of my literary genius, but I understand it's more about my being seen as a champion of gay rights. Ironically, I lived during what was called the gay nineties (1890s that is), but it had a totally different connotation.*

CC: Your grandson Merlin Holland wanted people to know that you were more than a rare wit quick with a bon mot, someone who today might even be a talk show host.

OW: *My fellow Irishman George Bernard Shaw said that I was "incomparably the greatest talker of my time—perhaps of all time." So maybe there is something to what Merlin suggests; perhaps a talk show where I could discuss with my guests the importance of creativity. I've always said, "Art should never try to be popular. The public should try to make itself artistic."*

CC: Honestly, I couldn't fathom why you didn't flee England for France when your friends begged you to. You would have escaped your trial and sentencing for your affair with the Marquis of Queensbury's son, Bosie Douglas.

OW: *I have always been true to myself and my art, to a fault, my friends would say in this case. Not advocating for a man who was sensitive and human, who could appreciate beauty, would be to deny all that I believed in. Well, I lost, but what a great battle to have fought! Sadly, a blow to my head during a fall in prison contributed to a nasty inner ear infection. It turned into cerebral meningitis, which led to my death on November 30. My last moments were spent in a rented room that had been my home since 1898, in the Hôtel d'Alsace, at 13 rue des Beaux-Arts in Paris.*

CC: Sadly, you were first unceremoniously interred in 1900 in the Bagneux Cemetery outside Paris—a shameful place for a man of your stature. Thankfully, once the scandal of your ill-fated relationship with Bosie had subsided and arrangements could be made, you were moved to Père-Lachaise in 1909, and a magnificent monument was created.

OW: *Fortunately, Bagneux was not my final curtain call. I would have envisioned something a bit grander, of course. Since my estate was bankrupt at the time of my death, there was a great concern over whether a permanent burial place, much less an appropriate monument, could be arranged. However, through the patronage of Helen Carew, a friend of mine and a member of my circle that included Max Beerbohm and H.G. Wells, the commission of a tomb was secured. My dearest Robbie, Robert Ross, my first male lover and the literary executor of my estate, announced the award of the sculpture commission to American sculptor Jacob Epstein at an elegant dinner at the Ritz Hotel where everyone was celebrating the success of the publication of my De Profundis. Robbie, following my death, spent many years buying back the lost copyrights for my plays and stopping the many unauthorized and pirated editions of my works.*

CC: I think you might have enjoyed the turmoil caused by your tomb's sculpture. It was the last scandal associated with you. Epstein created a markedly virile winged sphinx with a very prominent male organ, crowned with a tiara, and emerging from a mass of stone.

OW: *Amazing that Epstein's creation channeled my flamboyance! He was certainly no stranger to scandal himself. The aggressive nudity of the sculptures he had just completed for the British Medical Association headquarters in the Strand had all of London up in arms. After all the governmental furor, I was thrilled to hear that the critics were in favor of his brilliant design for my monument. In 1912, after nine months of intense work, he finished my tomb and opened his studio for a press preview. After the Strand controversy, he was surprised at their praise: "Seldom in this country are we permitted to see such a dignified piece of monumental sculpture."*

CC: Unfortunately, the support was not shared by officials of the City of Paris.

OW: *(Sighing) Yes, how tiresome. I'm appalled at the time wasted by clueless bureaucrats who attempt to determine what is and what is not beauty. I understand that the prefect of the Seine and the Conservateur of Père-Lachaise banned the work from going on public view due to the enormity of my, well, the statue's genitals. They threw a tarpaulin over the entire monument, and two gendarmes were posted at its side. After a one-month delay in the installation at Père-Lachaise, Epstein continued to work on fine-tuning the elaborate headpiece on the figure and, following a compromise, Robbie acquiesced to having a bronze leaf cover the offending parts; he refused to attend the final unveiling. As with most baseless efforts at censorship, the controversy faded into obscurity and after a time both the fig leaf and the tarp were quietly removed.*

CC: Even as late as 1961 the tomb was creating controversy again. Two Englishwomen walking in Père-Lachaise could not control their indignation when they saw the sculpture's frankly male parts. The ladies (or so the folk story goes) took stones from the border of the walk and broke off the testicles. One of the cemetery caretakers delivered these artifacts to the office of the conservator, where they served as paperweights before their subsequent disappearance.

OW: *I have never been concerned with people's fears or prejudices—myth or*

otherwise. What is important today is that my monument is a place of pilgrimage for people from all strata of society. I appreciate the flowers and letters left for me, addressed to the "the martyred poet," as well as their paying respects to my lifelong friend and champion Robert, whose remains are entombed with me. Robbie chose the epitaph from De Profundis, *which is carved into the stone.*

"AND ALIEN TEARS WILL FILL FOR HIM
PITY'S LONG-BROKEN URN
FOR HIS MOURNERS WILL BE OUTCAST MEN
AND OUTCASTS ALWAYS MOURN."

CC: Mr. Wilde, I deeply regret that in some aspects not much has changed in the hundred years since you passed. Though some countries now recognize same-sex marriage, others have called for gay people to face life imprisonment or, in some cases, execution if they are convicted of being homosexual.

OW: *"The evolution of man is slow. The injustice of man is great."*

CONVERSATION WITH EDITH PIAF

DIVISION 97, TOUR THREE

Edith Piaf's sleek, dark gray tomb is always bedecked with flowers. It might be a simple, single-stem rose or a garland wrapped in a French tricolor sash. She is beloved, and hers is one of the most visited graves in the cemetery.

"*La vie en rose*" was her signature song. She wrote it and first performed it in concert in 1946. Its literal meaning is "life in pink," meaning "a rosy life." The lyrics tell about the joy of finding true love and its timely appeal was to those who had survived the difficult wartime.

For me, however, the most stirring of her repertoire is "*Non, je ne regrette rien*" (No, I don't regret anything). She had planned to retire at age forty-four, but two young French songwriters, Charles Dumont and Michel Vaucaire, were determined to show her their recent compositions. Piaf's housekeeper let them in without her knowledge. Piaf was not pleased. She generally did not like Dumont's songs due to the low key in which he wrote. She kept him and Vaucaire waiting for an hour before meeting with them.

She commanded Dumont to sit down at her piano and play. He sang in a low voice and when he finished there was complete silence. She said, "Sing it again." Half way through she exclaimed, "This is the song I have been waiting for!"

I place a rose on her tomb as we begin our conversation.

Carolyn Campbell: Madame Piaf, Why do you sing? And when did you start?

Edith Piaf: *For me, singing is a way of escaping. It's another world. I'm no longer on earth. I sang to survive as a child.*

CC: Was there joy in it then; when you had to sing in the streets as a young girl to make your way?

EP: *Yes, I am completely happy when I sing. My other choice back then was to earn money for my pimp by being a tart. Instead, I spotted rich women in the bistros for him to rob. I lived in a world of thieves and prostitutes in Pigalle.*

CC: To be only seventeen with a two-year-old daughter, it had to be unbelievably tough.

EP: *When my daughter died of meningitis, my husband and I thought our world would end. I was doing whatever I could to earn just enough to eat. I was numb. Not knowing how to go forward.*

However, a cabaret owner, Louis Leplée, discovered me and taught me the basics of stage presence. He told me to wear a black dress, which later became my trademark. He booked me into a high-end night club where Maurice Chevalier spotted me and declared that I had it all. My professional life changed overnight.

CC: Sounds as though you had finally found easy street.

EP: *Well my self-confidence certainly got a boost, but two weeks later poor Louis was murdered. With my criminal reputation, the police came after me as a suspect.*

CC: Oh no. What happened?

EP: *Once again a man came to my rescue and the police did not charge me. Librettist Raymond Asso helped me not only by getting me out of that fix but by guiding me in my career. Softening my rough edges and helping overall. I was mean to him though. I've always had an impossible character. I threw things. I acted out. I was self-centered and insecure.*

CC: The boxer Marcel Cerdan seemed very different.

EP: *Who knew that a man who was a brute for a living could give me lessons in kindness and generosity?*

CC: How so?

EP: *He was a world champion but devoted himself to others. He turned over a winning fee to a center for children suffering from TB. He told me that I must always be kind to other people. Me, I was pretty much about me and my needs. I thought life was meaningless. That men were beasts. Living life fast and waiting to die. When I shoved my autograph-seeking fans away one night he told me he was disappointed. I was tired I told him. I was all nerves. He reminded me of the time before I was famous and had been longing for these people who were*

bringing their love to me. One day they all may be gone.

CC: That had to be a wake-up call.

EP: *In my own way I finally got to show him how deep down I did care through my singing. One night when we went to a fair to enjoy the rides; the crowd asked me to sing "La vie en rose." For the first time Marcel saw me with my gift to them. He said, "You bring them happiness and love."*[3]

CC: He seemed your match.

EP: *Marcel was the love of my life, yet it was also my darkest of days. Our affair was short-lived, as he was killed in an airplane crash. I started doing heavy drugs.*

CC: I am familiar with the cycle. We cover the pain with anesthesia. Sometimes it's a man, food, shopping. For others it's a drink or a drug.

EP: *Yes, it was morphine. Shots to get on stage. Shots to just be. I was suffering from so many ailments: insomnia, rheumatoid arthritis, injuries from a serious car accident, an ulcer, my alcohol consumption, the pills. Fear in general. Much of it stretching back to my trauma as a child.*

CC: Tell me about your parents.

EP: *My father was a street performer. My mother abandoned me at birth. At the end she died alone in her room while injecting herself with an overdose of morphine. At this point, with Marcel gone, it was all too much. I went in to take a cure. I thought I had finally surrendered.*

CC: You know, Edith, an addict is never really cured. The disease is only arrested. I am so sorry that you didn't have twelve-step rooms where lots of people are there for you. Some say a spiritual awakening is necessary. I see you wearing a ruby crucifix in photos. Does it reflect your spiritual practice?

EP: *Marlene Dietrich gave me that necklace. I was a devout Catholic and prayed to the saints. I also believed in the afterlife. Death is only the start of something. I had séances all the time and carried a table with me to every performance venue. The dead have reached out to me with warnings through my dreams as well. I didn't take a flight one time due to a dream. I later heard that the airplane had crashed.*

CC: I focused on death and impermanence for two years as part of my meditation practice. My teacher suggested I drive around as if death were in the back seat. Then, every once in a while at a stop light imagine that death would come. Like that—life would be over. It put me in touch with life itself—made me become deeply aware that we only have today.

EP: *I agree with that. I was grateful for each day. Though I was suffering I never stopped singing and writing. I think I created around 100 songs, both for me as well as others.*

CC: I think your songs were prayers. Certainly describing love can also be an expression of dealing with pain.

EP: *I made so much money; millions and millions. It didn't help. My home was decorated by the best designers, but I couldn't live in the rooms. I preferred the concierge's space. I would buy so many gowns at the couturiers and come back and put on my simple black dress.*

CC: You seem to have had great wealth in your love life.

EP: *Yes, I had many lovers and many male friends. I helped them with their careers, though people thought I slept with them all. My last love was Theophanis Lamboukas; I named him Théo "Sarapo," the Greek word for love. He was twenty years my junior and was the biggest joy of my life. I feared people would talk, so I resisted accepting his marriage proposal. He surely knew that even at forty-seven, I was at the end of my life. Yet, we had a glorious seven months together as man and wife. Je ne regrette rien.*

Our conversation was drawing to a close. I thought about her early life, the hardship and despair she'd experienced. I marveled that with all her trials, she had channeled her pain into art and still embraced "life in rosy hues." I asked her one last question.

CC: What did you find most important?

EP: *Carolyn, "The essential thing is to love, to be loved, to be happy and in harmony with yourself."*[4]

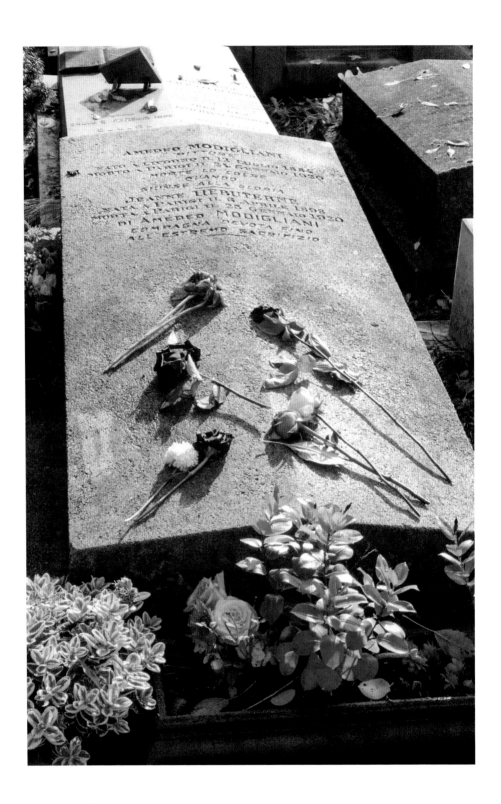

Conversation with Amedeo Modigliani
Division 96, Tour Three

Walking across the cobblestone road that is catty-corner from Edith Piaf's grave, there is a small tree overrun with ivy. Just on the other side of it is a low granite slab marking where painter and sculptor Amedeo Modigliani and his artist partner Jeanne Hébuterne are interred.

Standing at the foot of the tomb, I ponder going back in time. I'd choose the Bohemia of Paris in the early 1900s. At the Café de la Rotonde in Montparnasse, I would join poet Guillaume Apollinaire, and artists Pablo Picasso, Sonia Delaunay, and Chaim Soutine. I would order a coffee or absinthe, depending on the hour, while the theatrically handsome Modigliani entertained us with recitations of Dante or sketched our portraits. The wine flowed freely, along with the opiates. Modi, as he was called, imbibed heavily in both. He displayed great charm but could also be belligerent and moody.

All those stimulants and the resulting behaviors were a subterfuge to cover up a long-held secret. Regardless of what people make of his excesses and his squalid life at the end, there is no denying his place in art history: The elongated torsos and necks, the vacant eyes of his subjects are iconic for their "beauty and strange dignity" and now command record prices at auction.

Now, in the quiet of the cemetery, I am eager to hear from the artist whether there was ever any peace or meaning wrought from what seemed to be a short life filled with brief success but countered by struggle, demons, and disappointment.

Carolyn Campbell: You arrived in Paris from Italy with very little in material possessions, though you came from a long line of wealthy Sephardic Jews and aristocratic intellectuals. Picasso, hardly one to take attention away from himself, said that when you were the only gentleman in Paris who knew how to dress. You were generous, well liked, and were called the Prince of Montparnasse and the King of Bohemia.

Amedeo Modigliani: *I was Dedo to my family, but Modi to my Parisian friends. It was a prescient label;* maudit *translates as* accursed. *It was a foreshadowing, I'm afraid. When I left Livorno in 1906, I packed a few clothes, some studio supplies, and a book of poems by Oscar Wilde that my mother gave me. I came to Paris to enroll in art school.*

CC: Though we are generations apart, I can relate. I moved away from home at age sixteen to go to the Maryland Institute College of Art in Baltimore. I arrived wide-eyed.

AM: *Paris itself was my classroom. It was a city of art and artists, and a time filled with great change and promise. Even though my family fortune was long gone, I did arrive with my immaculate Italian suits, cape, and spats. I traded them for chocolate-brown corduroy pants belted with a red sash as well as a blue velvet jacket, checked shirt and a wide-brimmed felt hat. It was my new uniform and reflected my love of the community of artists in Montmartre and Montparnasse.*

CC: I had no idea how exciting yet confusing it was for me to go straight from an all-girls private Catholic school and be thrown headlong into the thick of a thriving artist's community. It was the late 1960s, and one of the most creative eras musically as well as the height of the experimental drug scene. There were wild times ahead, making art and love.

AM: *I was introduced to hashish in Paris. Baudelaire whose poems I admired wrote extensively about its effects of transcending, "the hopeless darkness of ordinary daily existence." I sought to accelerate my artistic goal; I wanted to reveal…the metaphysical architecture—to create my own truth, on beauty and on art. Little did I know that between hash, alcohol, and my declining health my brutish nature came out and alienated everyone.*

CC: Yes, it can all seem so idealistic at first. However, your goal was achieved in what you left behind. But, we are getting ahead of ourselves. I would like to know who made up your community in Paris. And how did you work together? My art school friends and I collaborated constantly. I was in their films and with my Rolleicord camera I became their portraitist. You would have made a wonderful subject.

AM: *I briefly shared a studio with Diego Rivera and painted him along with many others, including Picasso, Soutine, and Jean Cocteau. A close friend, the sculptor Jacob Epstein and I also shared a studio. He helped me get two of my sculptures into an exhibition at the Whitechapel Gallery in London in 1914. In 1915, I showed in New York for the first time. I participated in some eighteen groups shows in the company of such great artists as Picasso and Matisse. But I never seemed to get the reviews that the wealthier artists did. You paid the critics for recognition back then.*

CC: I would love to know more about your intimate friendships. I understand that you loved numerous women. And many of your friends and lovers became your models. Is that true?

AM: *Many women posed for me, but I immortalized my dear muse and mistress, Jeanne Hébuterne, with her pale, slender body and long, wavy reddish hair in twenty canvasses and hundreds of drawings. She was the last woman in my life.*

CC: You were a prolific artist and created close to a thousand works before your death at age thirty-five. What drove you?

AM: *I had always been in poor health since I was a child, having had typhoid and pleurisy before I was sixteen. While living a fairly debauched life in Paris, I suspected the worst when I began coughing up blood. Consumptives were shunned, and I did all I could to hide my illness, putting many at risk since tuberculosis is highly contagious. I continued to use hashish and brandy to halt the spasms. And then the drugs and alcohol used me. It was a deadly cycle. The pressure of my declining health and the exhaustion of trying to overcome my lack of faith in myself drove me into the studio where I worked even harder. Time was running out.*

CC: Toward the end, you were living in dire poverty and starvation. Did sales

of your artwork not give you some income? I hesitate to even tell you that your work now sells for tens of millions of dollars.

AM: *I probably would have lost it all. I wasn't good with finances, and when my works did sell, I squandered the money. I barely eked out a living and hardly looked after myself, much less Jeanne or our daughter. We lived in a squalid apartment on the Rue de la Grande Chaumière. Thank goodness for my first patron Paul Alexandre, and the dealers Paul Guillaume and Leopold Zborowski, who looked after my creative affairs as best they could over the years.*

CC: Your dealers would envy how a portrait you did of Jeanne in 1919 sold at auction for $27 million in 2006. In 2010 your 1917 portrait *Nude Sitting on a Divan* sold for $68.9 million, and in 2015 your 1917–18 canvas *Nu couché* sold for $170.4 million. I am sure Paul and Leopold tried to protect your work, but toward the end I heard that much was lost.

AM: *When I was dying, much of my art disappeared from my studio. Suspiciously, a gallery on the right bank mounted a show of twenty paintings the same day as my funeral, asking ten times the normal price.*

CC: How horrible. It seems your secretive nature as well as enormous pride worked against you, since none of your many friends were there to help you at the end.

AM: *I had run out of coal, the studio was freezing, and I didn't feel like eating. I had lost most of my teeth and had totally isolated myself from my fellow artists. Jeanne went for a doctor, who said I was suffering from kidney problems. The same doctor came back saying that my spitting up blood was due to stomach problems and suggested waiting until the bleeding stopped. That wrong diagnosis sealed my fate.*

CC: That is heartbreaking; had your friends only known. But I have lost dear people in my life who suffered in silence. You can't help them if they push you away. They may need it but they must want it in order to let you in.

AM: *Nothing was done for several days, and I was finally taken to the hospital in the Latin Quarter on Rue Jacob where the doctor's analysis of my condition at the end was a miserable litany of ailments—nephritis and alcohol poisoning on top of tubercular meningitis. This accounts for my horrendous headaches, sensitivity to light, and radical mood changes. I rambled endlessly due to my*

delirium before the end. I think my last words before falling into a merciful coma were "Cara, cara, Italia." (Dear, dear, Italy). I died two days later.

CC: Tragically, Jeanne, who was eight months pregnant with your second child, flung herself from the window of her parent's sixth-floor apartment the day after you died. May I ask how your two funerals were handled?

AM: *Sculptor Moïse Kisling made my funeral arrangements, insisting that they "bury me like a prince." My funeral procession walked the eight kilometers from the Charity Hospital to the cemetery. It included Max Jacob, Constantin Brâncuși, André Derain, Jacques Lipchitz, Picasso, Ferdinand Leger, Suzanne Valadon, Maurice Vlaminck, and many, many artists, writers, and poets. A rabbi recited prayers at my graveside.*

All Paris came to Père-Lachaise, and the floral wreaths were boundless—in stark contrast to the pathetic treatment given to Jeanne. Her family, totally ashamed by what they deemed her scandalous relationship with me, refused my friends' request to have a double funeral; instead, they took her to the outskirts of the city to Bagneaux cemetery. Suicides were not allowed to be interred with any ceremony. A decade later her family relented and had her remains interred with mine in Père-Lachaise.

As I gaze down at Modi's simple stone marker, its modest symbolism a stark contrast to the handsome, vibrant young man who was once a crown prince among artists. He gave everything to his art. In fact, all of him until there was nothing left.

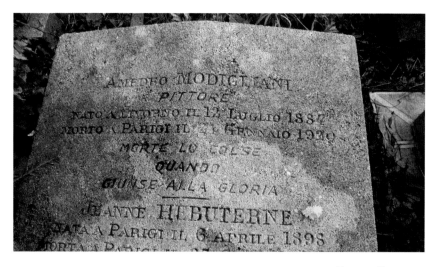

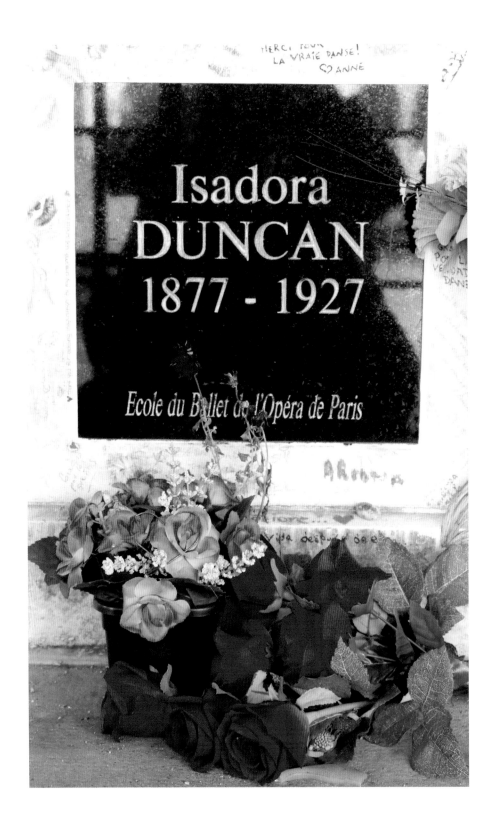

Conversation with Isadora Duncan

Division 87, Tour Three

One of the many privileges during my fourteen years at UCLA's School of the Arts and Architecture was working with the students and faculty in dance. A friend and colleague Emma Lewis Thomas, professor emerita of dance history, said of dancer and choreographer Isadora Duncan, "She carried the ideals of romanticism to their farthest reaches…would that we all could follow her call, 'I am going to dance the philosophy of my life.'"

The UCLA Library acquired the largest private collection ever assembled of rare materials by and about this modern dance pioneer. As I sat in the campus library reading Isadora's letters and leafing through dozens of her performance stills, it reminded me of the joy I have had in dancing. One performing gig even helped pay my rent while I was a college student.

Once I arrived at her burial niche in the cemetery's Columbarium, I spoke gently when I introduced myself not only out of respect for Isadora but for her two young children whose ashes are interred with her.

Carolyn Campbell: I understand you were born in San Francisco and raised in Oakland, California. Your family was poor, and you and your siblings taught local children in dance classes. Agnes De Mille in her book, *Dance to the Piper*, wrote: "It's no accident that California produced our greatest dancers, Duncan and (Martha) Graham. The eastern states sit in their folded scenery, tamed and remembering, but in California the earth and sky clash, and space is dynamic." How did the West affect your aesthetic?

Isadora Duncan: *My movements have sprung from the great nature of America, from the Sierra Nevada, the Yosemite Valley, from the Pacific Ocean.*

They have sprung from what Walt Whitman calls "the flashing golden pageant of California, the sudden and gorgeous drama"—the creative spirit of the West.

CC: It seems not only your movements but what you wore when you performed that was revolutionary. A Paris couturier stated that women's modern freedom in attire is largely due to you. "She was the first artist to appear uncinctured, barefooted and free."[5] You must have looked like one of the robed figures sculpted on the frieze of the Parthenon.

ID: *I felt it was my religious mission to revive dance—free form as opposed to ballet—from the two-thousand-year dormancy it had suffered since the days of ancient Greece. The loose tunics that I wore were as much homage to ancient Greece as a rebuke to the restrictions on corseted ballet women.*

CC: Initially, you didn't spend much time in the United States but moved to Europe. Did you find more acceptance of your choreography there?

ID: *I had some theatrical experience in the Midwest and on the East Coast but my first stop in London proved successful, followed by Paris and twenty sold out performances in Budapest. But it was in Berlin where I triumphed. I also started my first dance school for children there, a lifelong pursuit to establish them all over the world.*

CC: I understand that you loathed ballet. Why is that?

ID: *In tribute to the classical female, I chose to wear loose-fitting tunics and bare feet, allowing my breasts and hips to be free. Unlike ballerinas, whose bodies are crippled and many times driven to anorexia. They are controlled by men in the classroom, at rehearsals, and on the performance stage. When I was in St. Petersburg, Sergei Diaghilev said even though I had deep disdain for ballet I was warmly welcomed by both the Russian ballet establishment and the public.*

CC: You drew a lot of creative people from different disciplines, not just dance, into your orbit, including some fascinating men.

ID: *I was a virgin until I was twenty-five, yet I quickly made up for lost time. I had marvelous lovers; men and women, and two children—a daughter, Deirdre, by avant-garde stage designer Edward Gordon Craig, and a son, Patrick, by Paris Singer, the heir to the sewing machine fortune. Craig was the love of my life. We were a good match, though he was married and had eight children, not all with his wife. We worked and toured together for three years.*

CC: I read your and Craig's letters in the archives at UCLA. It was a passionate exchange of two powerfully creative people. But your consistent passion has always been children. I admired you adopting several of your students, who performed as the Isadorables and the Isadora Duncan Dancers of Moscow. We haven't touched on the loss of your own children in a tragic accident when the car they were in rolled into the Seine, where they drowned. How did you mourn that loss?

ID: *I kept busy but, in looking back, I never really recovered. After my sister took over the children's dance school in Berlin, I opened a school of dance for children in Bellevue near Paris, and attempted to open another one in Moscow. A healthy distraction as I pursued my dream. I later met a twenty-six-year-old man (I was forty-five) that I would marry, the poet Sergei Yesenin—another distraction from my grief? It was tumultuous; we broke up, and two years later he had a mental break down and committed suicide.*

CC: This is heartbreaking. Half of your life was spent in building a glorious legacy. This later period is such a dark chapter.

ID: *I moved to France, where I would spend the rest of my life, and wrote my memoirs to earn some much-needed income. I rarely danced again. Drinking became my pastime. My zest for fast cars and young men did not cease, however, and I took that fateful ride where my scarf caught in the spokes of a car. I died immediately from a broken neck.*

CC: Regrettably, we have no footage of your performances. I would love to see what so many wrote about: strong legs moving out from the panels of your diaphanous tunic, step, lift, step. Head thrown back, the arc of your neck, arms open, and your energy emanating from your solar plexus. And I love that you performed to the music of Chopin.

ID: *Interesting that people found my dancing to classical music radical and some critics objected. I say, why not move to those musical masterpieces? I never wanted to be filmed. I didn't want dancers to mimic my work or to follow in my footsteps but rather to go on their own artistic journey. "I believe that the era in which we live lasts but a moment and that every soul, from life to life, from era to era, from star to star follows a path to final perfection. I understand that the life of man is only a breath. However, the pilgrimage of his soul is eternal."[6]*

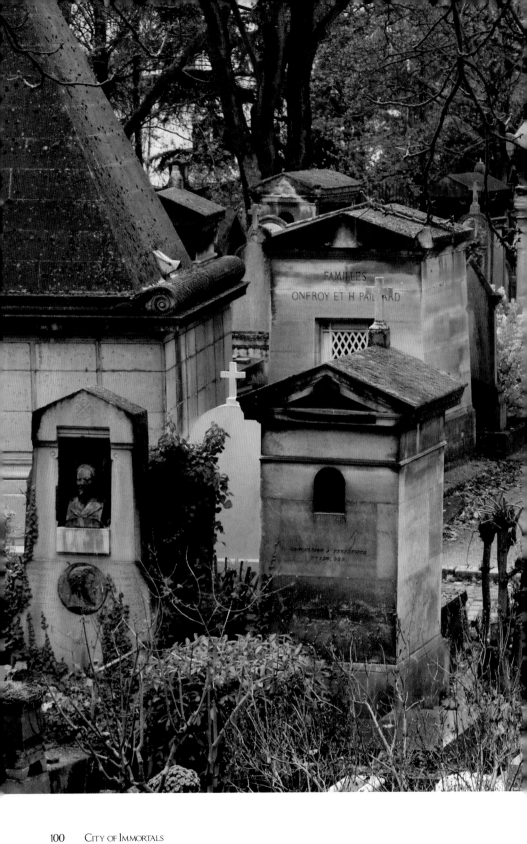

C HAPTER FOUR

V ISITING PÈRE-LACHAISE CEMETERY

It gives me great pleasure to share the beauty and mystery of Père-Lachaise Cemetery with others. The legacy of the cultural icons, rebels, intellectuals, innovators, and rule-breakers buried here reminds me of the importance of taking risks and giving voice to whatever creative contribution you leave behind. After more than three decades of sketching charts and diagrams, and locating hard-to-find plots with the help of cemetery staff and fellow graveyard lovers, I created the map and tours of Père-Lachaise.

The three custom tours guide visitors through the 107 acres (43 hectares) and 97 divisions. While there are scientists, politicians, and several of Napoléon's generals interred here, these tours feature the final resting places of eighty-four cultural icons with brief descriptions of each creative spirit as well as directions to each gravesite to complement the fold-out map.

Imagine being here a century ago, hearing the rhythmic beat of the sturdy black carriage horses' hooves drawing the hearses of people such as Frédéric Chopin, Honoré de Balzac, and Sarah Bernhardt. Envision the long processions of families, friends, and fans, heads bent in sorrow, carrying ornate floral wreaths to lie at the gravesites. Leaving the noise of Paris behind, we enter the hushed Elysium of the afterlife.

The cemetery is open to the public, and there is no admission charge.

CEMETERY ADDRESS AND CONTACT INFORMATION

16 Rue du Repos, 75020 Paris, France

Phone: +33 1 55 25 82 10

CEMETERY HOURS

From: November 6 to March 15
Monday-Friday: 8h to 17h30 (8 A.M.-5:30 P.M.)
Saturday: 8h30 to 17h30 (8:30 A.M.- 5:30 P.M.)
Sundays and bank holidays: 9h to 17h30 (9 A.M.-5:30 P.M.)

From: March 16 to November 5
Monday-Friday: 8h to 18h (8 A.M.-6 P.M.)
Saturday: 8h30 to 18h (8:30 A.M.-6 P.M.)
Sundays and bank holidays: 9h to 18h (9A.M. to 6 P.M.)

Administrative Office Hours:
(if you need help finding a family member's tomb)

Monday-Friday, 8h30 to 12h30 and 14h to 17h30
(8:30 A.M. to 12:30 P.M. and 2 P.M. to 5:30 P.M.)

There are three sets of restrooms on site. One on the left as you enter the main entrance at Boulevard de Ménilmontant; one near the entrance at Porte Gambetta, and one near the Administrative offices—see the end of Tour One. However, due to a high volume of visitors, they may run out of supplies. It's suggested that you bring tissues.

If you see a group of people with cars and a hearse nearby, there is probably a funeral service in progress. Please be respectful. Observe silence and behave appropriately.

No dogs are allowed in the cemetery.

Eating and drinking on cemetery grounds is not permitted.

No tripods are allowed, and professional or commercial photography must have prior approval.

Do not remove any items or mark the gravesites.

The hilly, sometimes steep paths are covered in leaves and moss (there are more than 5,000 trees in the cemetery) and are paved with loose gravel or cobblestones, so it's important to wear comfortable, sturdy shoes. A walking stick is highly recommended for those who wish further stability. Be prepared for unpredictable weather, so check reports in advance and bring an umbrella; it can rain unexpectedly. Wear layers of clothing, as the height of the location lends itself to blustery winds in fall and winter.

Please note that the cemetery may close due to heavy rains, snow, or strong winds because of possible falling branches from the many trees on site.

A bell will sound when it is closing time. Please move promptly to the exits.

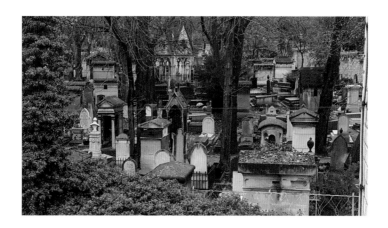

Tour One

Tour One covers a large portion of the oldest area, the Romantic section, which is part of the original sixteen-acre (six and a half hectare) area of the cemetery founded in 1804. However, you'll also come across many graves from the twentieth century amidst the older tombs.

Père-Lachaise Metro Stop

The Père-Lachaise Metro stop on Boulevard de Ménilmontant was designed by the *art nouveau* architect Hector Guimard, who also designed several *art nouveau* tombs in Père-Lachaise. Guimard designed 141 Metro entrances throughout Paris that were constructed between 1900 and 1912. Eighty-six still exist. Built in cast iron, they make heavy reference to the symbolism of plants and are now considered classic examples of French *art nouveau* architecture.

Side Entrance across from the Père-Lachaise Metro Stop

This side entrance across from the Père-Lachaise Metro station on Boulevard de Ménilmontant is open during regular hours. From the Metro station exit, cross Ménilmontant to enter the cemetery. You will find yourself on Avenue de l'Ouest facing the corner of Division 62 on your right and Division 63 on your left. The brick guard house is above the entrance stairs inside the cemetery.

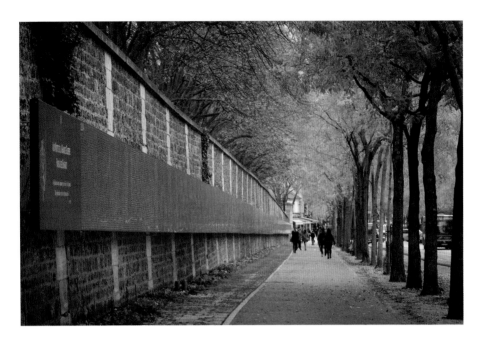

Monument aux Morts Parisiens

There are many war memorials built throughout France honoring the men and women who died in WWI. In Paris you will find them in churches or gardens. However, until 2018 there has never been one monument dedicated to all 94,415 Parisians killed in action. On the centenary of the Armistice (November 11, 2018) the *Monument Aux Morts Parisiens* inscribed with all 94,415 names, was inaugurated along the Ménilmontant perimeter wall by Mayor Anne Hidalgo.

The monument, created by the artist Julien Zanassi, consists of 150 steel blue panels 280 meters long and 1.8 meters high. The signage features a quote: "Qui donc saura jamais que de fois j'ai pleuré / Ma génération sur ton trépas sacré." (Who will never know how many times I cried / My generation on your sacred demise.) The lines were written by Guillaume Apollinaire, who became a naturalized French citizen in 1916. He fought at the front in Champagne as lieutenant of the 96th Infantry Regiment. Weakened from shrapnel injuries, he died on November 9th, 1918, just two days before the Armistice, from the Spanish flu. Apollinaire's grave is located in Division 86, (Tour Three).

Boulevard de Ménilmontant Main Gates

The main entrance to Père-Lachaise Cemetery on Boulevard de Ménilmontant was designed by architect Étienne-Hippolyte Godde. It consists of a horseshoe-shaped driveway with a pair of tall central gates topped by two carved medallions or wreaths, a symbol of wisdom or victory over death, bearing the classic funerary symbols of the torch (life's flame), and the hourglass (time passing).

Restrooms Inside Main Gates

To the left as you enter the cemetery and behind the guard station, you will find a row of modest restroom stalls. Full bathrooms are near the administration office noted at the end of this tour.

Sidonie-Gabrielle Colette

What a wonderful life I have had. If only I had realized it sooner.

—Colette

Walking up the cemetery's Avenue Principale, just inside the Boulevard de Ménilmontant main gate, you pass between rows of impressive crypts adorned with classical pediments and pilasters. At the cross street of Avenue du Puits, on the left is Division 4. Stop at the second gravesite on your right, the burial place of writer Sidonie-Gabrielle Colette (1873–1954).

Colette was one of the leading literary figures in France and the author of dozens of books, including *Chéri*, *La Naissance du jour*, and her most famous work, *Gigi.*

Even though Cardinal Feltin, Archbishop of Paris, refused Colette a church burial service due to her multiple divorces, the French government had awarded her the rank of Grand Officer of the Legion of Honor just after her eightieth birthday, so she was entitled to full military honors at death. She was the first Frenchwoman to be honored with a state funeral, the highest posthumous tribute that could be paid a French citizen. Thousands visited her coffin, which lay in state on a raised, funeral catafalque in the *cour d'honneur* of the Palais-Royal.

Louis Visconti

Turn back onto the Avenue Principale and head up the center walkway; on the left is the grave of architect and designer Louis-Tullius-Joachim Visconti (1791–1853).

In addition to his designing the Molière and Saint-Sulpice fountains in Paris, he was also the architect for the New Louvre (note the bas relief of that building at the tomb's base) as well as Napoléon's crypt beneath the dome in Les Invalides.

The reclining figure of Visconti was created by sculptor Victor Edmond Leharivel-Durocher (1816–1878) and the tomb was designed by architect Louis Villeminot (1826–1914). Ennio Quirino Visconti, an archaeologist and the father of Louis, is also buried here and memorialized with a bust created by sculptor David d'Angers that rests in a niche above the tomb.

Gioachino Rossini

A few steps farther and you will find the gravesite of composer Gioachino Rossini (1792–1868) who wrote one of the world's most popular operas, The Barber of Seville.

The last of Rossini's thirty-nine operas was *William Tell*, the overture of which is popularly known as the theme to the *Lone Ranger.* Following his creation of *William Tell*, he went into semiretirement, although he continued to compose cantatas, sacred music, and secular vocal music. According to the *Oxford History of Western Music*, "Rossini's fame surpassed that of any previous composer, and so, for a long time, did the popularity of his works. Audiences took to his music as if to an intoxicating drug, or, to put it more decorously, to champagne, with which Rossini's bubbly music was constantly compared." Although his remains were repatriated to the Basilica of Santa Croce in Florence, Italy, the city of his birth, in 1887, visitors to Père-Lachaise may still see his magnificent chapel-style crypt.

Alfred de Musset

Close by and further up the walkway is the gravesite of dramatist, novelist, and poet Alfred de Musset (1810–1857).

A former lover of the writer George Sand, de Musset wrote his best work after the unhappy relationship ended. His celebrated autobiographical novel, *The Confession of a Child of the Century*, recounts this affair. Composer Georges Bizet based several of his works on de Musset's poems. The writer died in his sleep of an apparent heart attack.

Charlotte de Musset

Visible behind Alfred de Musset's tomb is the burial place of his sister, poet Charlotte Amélie Hermine Lardin de Musset (1819–1905).

We find the elderly Charlotte portrayed in a granite sculpture seated with her hands folded over a slightly opened book held loosely in her lap. Her gaze appears lost in thought, maybe contemplating a sonnet she wants to share with a visitor.

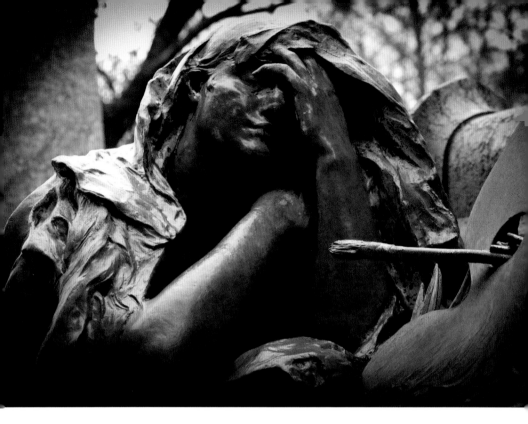

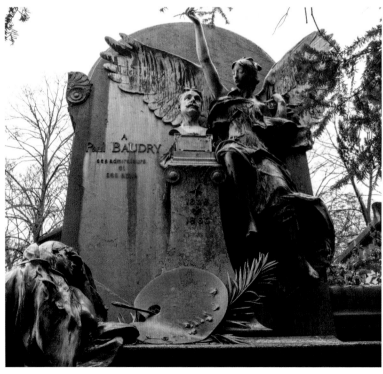

Paul Jacques Aimé Baudry

Just ahead on the left is the tomb of painter Paul Jacques Aimé Baudry (1828–1886).

At eye level is a female figure, obviously overwhelmed with sadness. She leans toward an artist's palette and brush rendered in bronze. The monument is a brilliant collaboration; Baudry's architect brother Ambroise and a friend, Marius Jean Antonin Mercié, designed the overall tomb; colleague Paul Dubois executed the bronze bust atop the base in the center, and Mercié created the two bronze figures: the woman on the lower left representing *Douleur* or Grief, and the other, a highly animated winged figure depicting Fame about to place a crown of laurels on Baudry's head.

During his career, Baudry was lauded for his highly colorful and imaginative murals, of which two can be seen in the Court of Cassation located in the Palais de Justice in Paris and at the chateau of Chantilly. In the afterlife, his equally artistic family and friends celebrated his memory with this division's most elaborate sculptural tribute to an individual.

Aux Morts

Taking the short set of steps behind you, proceed to a startling tableau: Aux Morts (To the Dead), *a large panoramic sculpture dominating the end of the avenue.*

Created by sculptor Paul-Albert Bartholomé (1848–1928), originally as a tribute to his wife, the monument features a mournful procession of twenty men, women, and children marching toward an immense dark doorway into the next life. The site also serves as an ossuary that contains the remains of many thousands of Parisians. When other cemeteries in the city were closed or when people's graves in Père-Lachaise were reclaimed due to negligence or for lack of rent payment, their remains were placed in the ossuary. The doors to the ossuary on the sides of the monument are closed to the public.

Paul-Albert Bartholomé

If you pivot back 100 feet (30 meters) to your right, you'll find the low, granite, lichen-covered tomb of Paul-Albert Bartholomé (1848–1928), which bears his likeness carved in an attitude of peaceful repose.

Though Bartholomé was schooled as a painter, his close friend artist Edgar Degas urged him to sculpt, though he had no formal training in the medium. Drawn to the popularity of funerary sculpture, Bartholomé was commissioned to execute a white marble bas-relief for the Dubufe tomb found in Division 10 later in this tour. Bartholomé's works can also be found in the Musée D'Orsay in Paris as well as the cemeteries of Montparnasse and Montmartre.

Head up to the top of the flight of stairs—the path is Avenue Latérale du Sud— and take a right onto Chemin Denon to the split-level Division 11. Please be careful as the pathways are uneven.

Arman

Entering right on Chemin Denon past Chemin Talma, on your right is an interior path, where you will soon discover the grave of artist Armand Pierre Fernandez, known as Arman (1928–2005).

Arman is best known for his "accumulations" involving the destruction and recomposition of objects, which the tomb's sculpture of a fragmented cello resembles. Born in Nice, he spent a great deal of time in New York. He had studios in the Bowery and TriBeCa and eventually became an American citizen. After his death in New York in 2005, some of his ashes were buried in this tomb in 2008.

Luigi Cherubini

Further down on your left and continuing along the edge of Division 11, you come to the composer of opera and sacred music Luigi Cherubini (1760– 1842).

Best known for *Médée*, which Cherubini wrote in 1797, his tomb was designed by the architect Achille Leclère and includes a relief work by sculptor Auguste Dumont representing Euterpe, the muse of music, crowning a bust of the composer with a wreath.

Frédéric Chopin

Four tombs down from Cherubini and following the iron railing along this same raised pathway, you will encounter a good friend of Cherubini, the celebrated composer Frédéric Chopin (1810–1849).

Having arrived in Paris when he was twenty-one, throughout his life Chopin longed for his native Poland. Though of small demeanor and frail health (he eventually died of consumption), he was in high demand in the leading Paris salons since nothing like his music had ever been heard before.

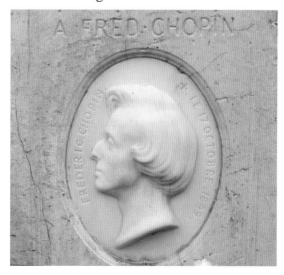

His death was commemorated with a funeral service at the Church of the Madeleine, where Mozart's Requiem was sung. His pallbearers, close friends, included the artist Eugène Delacroix and cellist Auguste-Joseph Franchomme. His tomb features a portrait medallion in marble sculpted by Auguste Clésinger and a figure of a girl representing the genius of music, head bowed in grief and holding a lyre with broken strings.

GABRIEL PIERNÉ

Stepping out onto the intersection of Chemins Denon and Méhul and walking back a distance to your left into Division 13, you will find the grave of conductor, composer, and organist Gabriel Pierné (1862–1937).

Among his many accolades is his conducting of the world premiere of Igor Stravinsky's *The Firebird* in 1910. The headstone designed by sculptor Henri Bouchard features a standing woman holding a theatrical masque of comedy while a seated young person (possibly Pan?) plays a flute.

IGNACE JOSEPH PLEYEL

Twenty paces farther up this path you come across the grave of prolific composer (forty-one symphonies), pianist, publisher, and piano manufacturer Ignace Joseph Pleyel (1757–1831).

Pleyel's eldest son Camille, also a piano builder, was a close friend of Chopin and a pallbearer at his funeral. I want to call attention to the close proximity of certain gravesites of several people who were known to each other in life, such as Chopin and Pleyel. This is intentional; just as family plots are planned in advance, friends also arrange to be close to one another in the afterlife.

ANDRÉ-ERNEST-MODESTE GRÉTRY

Turn around and cross over Chemin Mehul, and you see a bronze bust atop a stone plinth within the iron-gated grave of André-Ernest-Modeste Grétry (1741–1813).

One of Napoléon's favorite composers, Grétry created over fifty operas. All but his heart rests here. That is interred beneath a statue of him in front of the Opera House in Liege, Belgium. Napoléon granted him the cross of the Legion of Honor. The portrait is of Grétry wearing his cross.

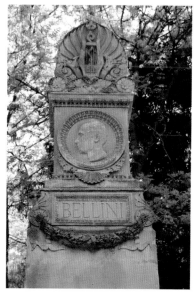

Vincenzo Bellini

Across from Grétry, you find the tall, narrow grave marker of musician Vincenzo Bellini (1801–1835).

The quintessential composer of bel canto opera, one of Bellini's greatest works is *Norma*, which he wrote in 1831. Look closely on the side of the tomb and you will find the titles of all Bellini's works—a novel way to ensure no one ever forgets his creative contributions. His spirit may rest here for visitors, but his remains were moved to Sicily in 1876. The sculptor Baron Carlo (Charles) Marochetti designed the medallion portrait of Bellini that appears on one side and top of the tomb.

Alexandre-Thèodore Brongniart

Keep walking to your right, and you will come upon the double plot (column with urn on the left and wide headstone on the right on the other side of the iron railing) of the man who designed Père-Lachaise Cemetery, Alexandre-Thèodore Brongniart (1739–1813).

A well-respected architect and landscape designer who was born in Paris, he was commissioned by Napolèon to design the cemetery. The emperor was so pleased with the cemetery's revolutionary layout that in 1807 he chose Brongniart to design the Bourse (the Parisian stock exchange). An image of the building is carved on the front of the one headstone on the

ABOVE: FAMILY BURIAL PLOT AND TOMB OF BRONGNIART.

right. He also designed hotels, including the Hôtel de Bourbon-Condé and the Hôtel de Monaco, and a number of exclusive private residences.

Both the column and the headstone are inscribed with Brongniart's name. His son, scientist Alexandre Brongniart, is also buried at the site.

FERNAND ARBELOT

It won't be hard to notice the tomb of Fernand Arbelot (1880–1942) to the left, inside the small Avenue Delille.

The grave features a bronze sculpture of a man lying down and gazing into a woman's disembodied face held aloft in his hands. Arbelot's profession remains a mystery. One source claims he was a musician or actor, and another suspects he was an architect. Whatever his creative affiliation, he is memorialized by a fascinating design in oxidized bronze by Belgian sculptor Adolphe Wansart. The inscription on the tomb reads, "They marveled at the beauty of the voyage / that brought them to the end of life."

François-Joseph Talma

Walking straight ahead to your left, you will see greenery that decorates the light-colored tomb of the French actor François-Joseph Talma (1763–1826).

A friend of Napoléon, Talma made his debut at the Comédie-Française and later became its lead talent. Known for his good looks, powerful voice, and great passion, he set the tone for theatrical dress and staging, and even introduced a Neoclassical haircut for men.

Théodore Géricault

Facing the large chapel close by, follow Chemin Talma back toward Chemin Méhul, turn left onto Avenue de la Chapelle. On your left about midway along the edge of Division 12, meet the artist Théodore Géricault (1791–1824).

You will not miss him as his reclining bronze figure looms over us. It was sculpted by fellow artist Antoine Étex. An early leader of the Romantic Movement, Géricault created works depicting contemporary subjects. One of his most famous paintings is *Raft of the Medusa*, in the collection of the Louvre. It is a highly political artwork depicting the horrendous shipwreck of the French frigate *Méduse* in North African waters where the captain abandoned at least 147 passengers and officers adrift in a makeshift raft. You will find bas reliefs of the Medusa painting and two other artworks by Géricault, *The Charging Chasseur* and *The Wounded Cuirassier*, executed by Étex. Look for the sculptor's signature at the base where Géricault reclines, nearest to his painter's palette.

As the result of a riding accident where he was thrown and landed on his back, complicated by disastrous treatment by a doctor, within several months Géricault succumbed to complications of pneumonia and tubercular decay of the spine. The funeral service was held in a small church, St. Vincent de Paul in Montmartre.

Charles-Philippe Lafont

Look just beyond the left side of Géricault's tomb, and a few steps away in a small clearing is the final resting place of composer and violinist Charles-Philippe Lafont (1781–1839).

Considered one of the best violinists of the French school, he travelled widely throughout Europe. His professional achievements include being a chamber violinist to Tsar Alexander I of Russia, and the first violinist of the royal chamber musicians of Louis XVIII of France. He died in a carriage accident at age fifty-eight.

James "Jim" Morrison

Prepare for a long walk heading southeast along Avenue de la Chapelle, where you come to the Carrefour Du Grand-Rond with the prominent statue of Jean Casimir-Périer, French banker and statesman, high on a pedestal in the center. Follow the circle halfway around and take your second right past Division 14. At the intersection of Chemins Lauriston and Lesseps take a right at that fork into Division 6.

The next burial place is one of the most controversial, hard-to-find tombs in the cemetery. You might detect the scent of marijuana wafting in the air or see graffiti and streams of young people leading to the grave, which is surrounded by metal barricades; this will identify the final resting place of legendary singer, songwriter, and member of The Doors, James Douglas "Jim" Morrison (1943–1971).

Morrison loved Paris, and in 1971, he moved there with his girlfriend, Pamela Courson. He wanted to take a break from the pressures of the meteoric rise of The Doors, the demands of a grueling concert schedule, and the constant onslaught of fans wanting more from the Lizard King. While in Paris, he reportedly fell back into alcohol and drug use and was found dead of a suspected heart attack in the bathtub of his apartment on the right bank. A small, private funeral was held with Pamela, his manager, and a few close friends in attendance. The low double plot is crowded between two tall crypts.

GEORGES RODENBACH

Stepping out of Division 6 onto Chemin Lesseps, follow it along a winding tree-lined road to Chemin Bernard, then take a right along Division 15.

You won't be able to miss the immense pyramid dominating this area, but you may be startled by the adjacent burial place of Belgian Symbolist poet Georges Raymond Constantin Rodenbach (1855–1898). A sculpture shows him bursting out of the top of his crypt holding a rose in his outstretched hand. The artist who created this astounding figure was French sculptor Charlotte Besnard, née Charlotte Gabrielle Dubray (1854–1931). The epitaph on the tomb reads, "Oh Lord, if I can return to this earth, let it be as a book of melancholy poems."

This area, like all of the sites on Tour One, features some of the oldest tombs in the cemetery. Look around and note the varying designs of crypts and family chapel-style tombs. In addition, overhead you will notice a leafy canopy created by thousands of trees throughout the cemetery to retain the gardenlike atmosphere. Songbirds in the branches above noisily announce your arrival at each mausoleum.

ROSA BONHEUR

Now wind back on the final leg of the tour. Follow Chemin Bernard, then take a right on Chemin Serré, which borders Division 74. Walk along this border and on your left; set back from the roadway and behind a large tree is the resting place of artist Marie-Rosalie "Rosa" Bonheur (1822–1899).

Bonheur was the most famous woman painter of the nineteenth century and the first renowned painter of animals. One of her best-known works, *The Horse Fair*, hangs in the Metropolitan Museum of Art in New York. She was born into a family of artists; her father was a disciple of Saint-Simon, who believed in the coming of a woman messiah. He was also a strong believer in equality for women. As a result of this paternal influence, Bonheur felt that women should make their own way. Her independence quickly garnered her a reputation as an eccentric for sometimes choosing to wear men's clothing, which she stated was necessary to research her subjects in stockyards and slaughterhouses.

Throughout the years, Bonheur lived with a lifelong friend, Nathalie Micas, and later Anna Klumke, her life partner. Klumke was a fine painter in her own right, and her portrait of Bonheur was purchased by Cornelius Vanderbilt, who eventually donated it to the Metropolitan. Klumke was with Bonheur at their chateau near Fontainebleau until her final days. Now, Nathalie, Anna, and Rosa rest together in a tomb that Bonheur purchased in Père-Lachaise. The simple granite monument that bears their names is decorated with a bronze palm frond bound with ribbon.

Francis Poulenc

Stepping back out into Chemin Serré and strolling to your left past the back corner of Division 6, you will arrive at Division 5, a little way past the corner of Chemin Lebrun. Here you find composer Francis Poulenc (1899–1963).

Poulenc was largely self-taught, yet he was a prolific, diverse composer. His compositions ranged from works for ballet, opera, and chamber music to choral pieces and orchestral concert music. His comic opera *Les Mamelles de Tirésias (The Breasts of Tiresias)* was based on a farce by Guillaume Apollinaire (Division 86, Tour Three).

Poulenc also wrote songs based on the work of other poets, including Paul Éluard (Division 97, Tour Three) and his work *Tel jour telle nuit*. It's hard to ignore the fact that so many residents of Père-Lachaise collaborated during their careers. For example, at the request of Sergei Diaghilev, Poulenc composed the ballet *Les biches*, premiered by the Ballets Russes in Monte-Carlo, with sets and costumes by Marie Laurencin (Division 88, Tour Three).

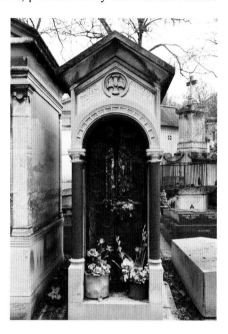

Poulenc suffered a fatal heart attack at his home at 5 rue de Médicis. At the composer's request, the funeral was held in the utmost simplicity, the only music being by Bach. Poulenc's resting place is a tall, narrow, chapel-style crypt with a lovely stained glass window.

The cemetery grounds are less hilly now, and you have a more comfortable path to follow the rest of the tour.

HÉLOÏSE AND ABÉLARD

Follow Chemin Serré to where it dead ends into Avenue Casimir Périer, and you will find one of the key landmarks of the cemetery in Division 7. Look for the tall architectural spires on your left and a small interior path. You now arrive at the cathedral-like crypt of the famed lovers—student and abbess Héloïse (1101–1164) and wealthy theologian and teacher Peter Abélard (1079–1142). Architect M. Alexandre Lenoir (1761–1839) created this cloister of ornately carved neo-Gothic arches, which was restored in 2006.

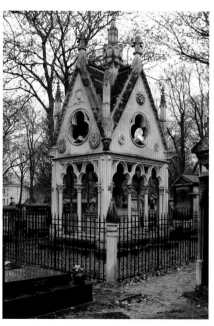

The forty-year-old Abélard seduced the sixteen-year-old Héloïse, and after her pregnancy, they were secretly married. But the career hopes of the seducer were dashed and the seduced went on to establish a nunnery. After going their separate ways,

they continued to write each other, and their letters provided significant insights into medieval French beliefs about romance, philosophy, and social mores.

Please view all sides of the tomb, so you don't miss the sculpted figure of a dog resting at the couple's feet symbolizing their fidelity.

CAMILLE PISSARRO

About ten yards west, you find yourself in the original Jewish section of the cemetery and before the modest family plot with a granite headstone marking the tomb of artist Camille Pissarro (1830–1903).

This revolutionary and innovative painter of landscapes as well as rural and urban French life was known as one of the leaders of French Impressionism. Among the artists that he mentored was Paul Cézanne, with whom he worked closely for several decades.

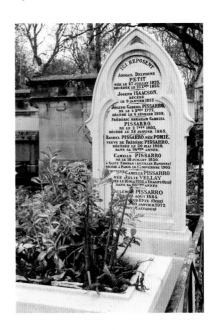

FAMILY DUBUFE

If your schedule allows, there are several more graves of interest in this immediate area. Step out of Division 7 toward Avenue du Puits, then take a right on Avenue

Laterale Sud to Division 10. On your right is a small path, Chemin du Père Éternel, which leads to the burial place of the Dubufe family on your left.

Interred within are painter Guillaume Dubufe (1853–1909) and his daughter, the painter and sculptor Juliette Dubufe (1879–1918).

The tomb was designed by architect Jean-Camille Formigé (1845–1926) who also designed the Columbarium in Division 87 (Tour Three). The bas reliefs—the reclining male figure at the top and the standing female grief figure—were sculpted by Paul-Albert Bartholomé, who also created the monumental *Aux Morts* you saw at the beginning of the tour in Division 4.

Mademoiselle George

Across this small pathway facing Chemin du Père Éternel on your right, you find one of the most famous French actresses of her time, Mademoiselle George, née Marguerite-Josephine Weimer (1787–1867).

An international artist celebrated for her great performances on stage from Stockholm to Constantinople, and from Brussels to Saint Petersburg.

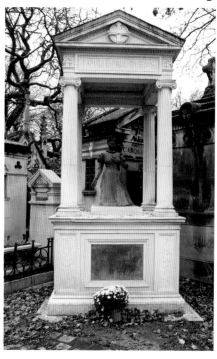

In addition, she seemed to be an accomplished performer in the boudoir as well. She had affairs with Napoléon I as well as the Duke of Wellington, and gave birth to a child, Maria Alexandrovna Parijskaia, fathered by Tsar Alexandre I of Russia.

Paul Dubois

Turning around, your final visit on Tour One in Division 9 is the burial place of the prolific painter and sculptor Paul Dubois (1829–1905).

The tomb is large with pillars, and a statue in the center by Dubois is

the artist's mother, Claudine Sophie Dubois, who died in 1834 at age twenty-six. Among his many achievements are the equestrian statue of Joan of Arc located in Place Saint-Augustin and the *Chanteur florentin du XVe siècle*, one of his best-known works on view in the Musée d'Orsay. Within Père-Lachaise, he created the bronze bust of composer George Bizet that used to sit atop his tomb found in Division 68 (Tour Two). It has been stolen and recovered once; cemetery officials have decided to avoid further vandalism by keeping it in storage. Dubois also created the bronze bust of Paul Baudry, whose tomb you saw at the beginning of the tour in Division 4.

Stepping out onto the wide center aisle, Avenue Laterale Sud and going west to Avenue du Puits, on your left you arrive back at your starting point at Avenue Principale. Turn left, and you face the main gates and your exit onto Boulevard de Ménilmontant.

Congratulations, you have just traversed sixteen acres and moved through a century of French cultural history.

Restrooms

Restrooms are around the corner from the Conservation/Administration Office. Should you have any questions about the cemetery or wish to research a family tomb do so in the office.

Rue du Repos Entrance

The #16 over the doorway is, in fact, the address for the cemetery on Rue du Repos. The doorway inside is adjacent to the restrooms. This exit leads out to Boulevard de Ménilmontant via the small side street Rue du Repos.

Tour Two

Tour Two covers some of the steepest areas in the cemetery (Père-Lachaise was formerly called Mont Louis and, yes, it is considered a mountain), so take that into consideration when gauging your hiking abilities and time available. It is important to tour at a reasonable pace, so you can explore as much of the area as your heart desires and your feet can tolerate.

Jacques-Louis David

Entering the cemetery's main gates on Boulevard de Ménilmontant and heading up Avenue Principale toward the large monument Aux Morts (To the Dead), *walk up the stairs on your left. After reaching the top of the stairs just ahead on your left in Division 56, you will find the burial place of artist Jacques-Louis David (1748–1825).*

A bronze medallion with his portrait is centered in the marble headstone resting atop a wide architectural base. Considered the preeminent painter of his time and best known for his Neoclassical style, his first teacher was French artist Joseph-Marie Vien at the Royal Academy in the Louvre.

The painter was obsessed with the soldier-emperor Napoléon Bonaparte and created several memorable and extremely flattering portraits (many are in the Louvre), including Napoléon's coronation, where the artist set up a large canvas to capture the moment. And what a moment. The pope, who would traditionally preside over such a momentous occasion, was only a figurehead. In fact, Napoléon took the gold laurel leaves from Pope Pius VII and crowned himself Napoléon I. David did such an impressive job with the magnificently large painting that Napoléon awarded the artist with the title First Painter to the Emperor. While leaving a theater in Brussels one night, a carriage struck him, and he later died. Due to his being a Bonapartist and his anti-establishment political beliefs, he was not allowed return to France for burial. His body was buried in Brussels Cemetery, though some say his heart is buried with his wife at Père-Lachaise.

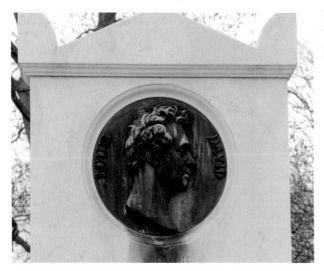

Attention, camera buffs: Depending on whether or not there are clear skies, I suggest you stand on the grassy area in front of the large chapel nearby on Avenue de la Chapelle. You can look out through the trees (during late fall or winter, without the foliage, is an ideal season) to see the Eiffel Tower off in the distance. If you find yourself here at dusk, the long lens photo opportunity will offer dramatic results.

MARCEL MARCEAU

IT'S GOOD TO SHUT UP SOMETIMES.
—MARCEL MARCEAU

Step out onto Avenue de la Chapelle, and past the large chapel on your left keep to the right of Division 21, pass Géricault on your right, turn onto Chemin du Bassin on your left, and then move into the center of this division, where you will see a white tombstone with a Star of David. Here lies actor and mime Marcel Marceau (1923–2007).

Named an Officer of the Legion of Honor by the French government in 1999, Marceau was one of the most popular entertainers of the twentieth century, and he actively performed, most notably as the character Bip, until his death. His grave marker stands out due to its light beige color among many older tombstones, and the Star of David in the headstone denotes that he was Jewish. Look for his signature inscribed at the foot of the tomb.

GUSTAVE DORÉ

After visiting Marceau's gravesite, walk about fifty-five paces directly in front of you towards your right, crossing over Chemin Berthollé (a small cobblestone path) and stepping far into Division 22 you will find a low, wide, moss-covered tomb of artist Gustave Doré (1832–1883).

It is a plain, large, flat tomb, and may be difficult to find. On my first visit, moss had filled in the etched letters of his name on the top of the granite tomb, so I scratched out the growth to reveal DORÉ. Today, someone has graciously filled in his name in gold leaf on the front panel of his tomb.

Considered one of the greatest illustrators of all time, his best-known artworks are found in editions of Dante's *Inferno*, Milton's *Paradise Lost*, and Edgar Allan Poe's *The Raven*. His illustrated French edition of Cervantes's *Don Quixote*, became the iconic example of the appearance of the knight and his squire, Sancho Panza and influenced many creatives, including those in stage and film of the two characters' appearance. The government of France made him an Officer of the Legion of Honor in 1861.

JANE AVRIL

As you cross over Chemin du Rassin to the intersection of Chemin de la Citerne and Chemin du Dragon, take about five paces into Division 19 and the resting place of Jane Avril (1868–1943). The grey headstone is simple; her name appears but is very faint.

The famed French cancan dancer is best known for her performing at the Moulin Rouge. Her fame was increased substantially when the artist Henri de Toulouse-Lautrec painted her portrait on a poster to promote the Jardin de Paris, a major concert venue on the Champs-Elysées. Zsa Zsa Gabor portrayed Avril in the original *Moulin Rouge* film (1952); half a century later, her semi-fictionalized character was reinterpreted by Nicole Kidman in *Moulin Rouge!* (2001). Avril's humble tombstone reflects her final days living in near poverty.

NICOLAS FROCHOT

The next gravesite necessitates traversing a long section of the cemetery and heading down a steep incline. Continue on Chemin du Dragon until you find a staircase on your right. Take that staircase down and then another that crosses the small Chemin des Chèvres down to Avenue des Acacias. Go to the left to Division 37 and eventually on the left walking uphill find the family crypt of politician Nicolas Frochot (1761–1828), who was prefect of the Seine.

Though my focus in *City of Immortals* is on artists, musicians, and other creatives, I have made an exception to include Frochot. Without his vision, Paris would not have such a cultural landmark as Père-Lachaise Cemetery. Napoléon designated that Frochot promote the cemetery and make it appeal to the populace. Frochot negotiated the land for the cemetery and did a masterful marketing job with the site. We owe him a great deal for helping create the rare museum-quality sculptures here and the vast array

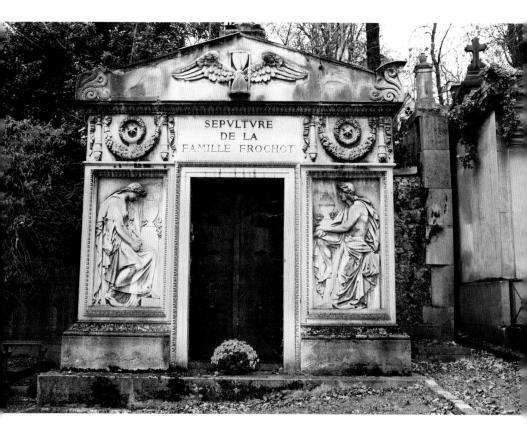

of high-end tombs. Frochot's considerable publicity skills set the tone for a competition among Paris's elite to erect mausoleums of extraordinary architecture by the leading ateliers of the day complementing the sculptures.

Sculptor Nicolas-Bernard Raggi created two reliefs on each side of the tomb's entrance. There are classic examples of funerary iconography carved in stone, including the reverse torches above the two figures (representing a life extinguished) and the winged hourglass in the pediment (illustrating time fleeting).

NADAR

Just sixteen paces on your right along Avenue des Acacias, you come to Division 36 and the tomb of Nadar, whose birth name was Gaspard-Félix Tournachon (1820–1910).

One of the most highly regarded photographers of the nineteenth century, Nadar is buried along with his son Paul, who took over his studio when he died. Nadar rests in a very modest grave with a simple granite headstone with his name engraved across the top portion. The tomb is set back a bit from the road between two trees.

Nadar numbered among his friends, who were also his portrait subjects, some of the most significant cultural figures of the era, many of whom are buried in Père-Lachaise. They include Sarah Bernhardt (Division 44, Tour Three), Gustave Doré (Division 22), Gérard de Nerval (Division 49), Honoré Daumier (Division 24), and Eugène Delacroix (Division 49).

David d'Angers

Move uphill on Avenue des Acacias where it meets Chemin Suchet et Masséna. Take a left and then a right on Chemin Camille Jordan. On your right about fifty paces ahead you will find a dirt path, go past a light-colored mausoleum and you will find the gravesite of sculptor, Pierre-Jean David (1788–1856). He adopted the name David d'Angers.

A winner of the Prix de Rome, he was a prolific artist who created full-size statues, busts, and portrait medallions of the era's major literary, political, and artistic figures, most notably Honoré de Balzac (Division 48). It is said that there are fifty-six works by d'Angers throughout Père-Lachaise. He was the sculptor of choice hired by clients to work with architects who were commissioned to design and construct tombs to complement the artwork d'Angers would create; many times, a bust of the individual interred in the tomb was cast in bronze.

Charles Percier and Pierre Fontaine

Across the chemin walk twenty-five paces on your right and you will find a tomb that is a pile of large stones. Behind that is a tall column with masonic symbols, which is the burial place of architects Charles Percier (1764–1838) and Pierre-François Léonard Fontaine (1762–1853).

Charles Percier, along with his architectural associate Pierre Fontaine, was largely responsible for the popularity of the Empire style of the era and were favorites of Napoléon. The pair were well known for their lavish designs for interiors and furniture, including work created in palaces (the Louvre and the Tuileries) and new residences of the Bonapartes. They designed the arcades of the Rue de Rivoli and the Rue de Castiglione, the Louvre, and the Arc de Triomphe du Carrousel. Fontaine designed the tomb in Père-Lachaise where they are interred together.

ANNA DE NOAILLES

Look for a large dome a short distance to the right and walk across this division to the final resting place of writer Anna de Noailles (1876–1933).

A Romanian-French novelist and poet, she was friends with the cultural elite of Paris, including Colette, Jean Cocteau, André Gide, Max Jacob, and Marcel Proust.

"Noailles composed nine volumes of poetry, three novels (among which the delightful *Le Visage émerveillé*, 1904), a collection of prose poems (*Exactitudes*, 1930), a book combining novellas with a series of meditations on gender relations (*Les Innocentes ou la sagesse des femmes*, 1923), and an autobiography spanning her childhood and adolescence (*Le Livre de ma vie*, 1932)."[7] She was the only female poet of her time in France to receive the highest public recognition. This chapel tomb houses not only Noailles but her grandfather Georges-Démètre Bibesco (1804–1873), Romanian prince of Wallachia, and his wife Marie Bibesco (1815–1859).

"The dramatic exterior hints at the stunning interior of this large chapel tomb: three large frescoes depicting religious themes stretch across the back half of the circular structure and a relief with two angels kneeling and praying one on either side of a portrait of a woman and dedicated to Marie Bibesco is found just below the altar. Sculptor/artists: Eugène Oudine (relief) and Jean-Baptiste-Auguste Leloir (frescoes)."[8]

Pierre-Paul Prud'hon

Walk across Chemin du Dragon that the Noailles mausoleum faces and step into Division 29. Near the massive rock gravesite is the tapered, marble column within an iron railing that marks the resting place of artist Pierre-Paul Prud'hon (1758–1823).

A French Romantic painter and draftsman, Prud'hon was best known for his allegorical paintings and portraits, many of which were commissioned by Napoléon. Educated at the Royal Academy Paris, he won the Prix de Rome Art Award in 1784. Prud'hon achieved fame and honor with an allegorical work *Justice and Divine Vengeance Pursuing Crime* (1808) in the collection of the Louvre.

His work for wealthy Parisians led him to be held in high esteem at Napoléon's court. He painted a portrait of both of Napoléon's wives. Under Nicolas Frochot's direction, he worked closely with the architect Charles Percier on the preparation of the interior of Notre Dame for Napoléon's coronation. The fall of the Napoleonic regime in 1815 inevitably damaged Prud'hon's artistic career, but he still remained a respected portraitist.

ALPHONSE DAUDET

Walking back out onto Chemin du Dragon, move onto Chemin Saint-Louis up to Chemin Molière et La Fontaine. At the signpost, look left, and you will see the corner of a small alley (not more than a dirt path) to the hidden but fascinating family crypt of author Alphonse Daudet (1840–1897). It may be difficult to find, as it is tucked in between two other tombs.

On a back corner of the tomb you will find a portrait medallion in bronze of Daudet by sculptor Alexandre Falguière atop *an art nouveau* column decorated with bronze palm fronds. Walk around the other side of the tomb and you will find a list of his books, including *L'immortel* (*The Immortal*, 1888).

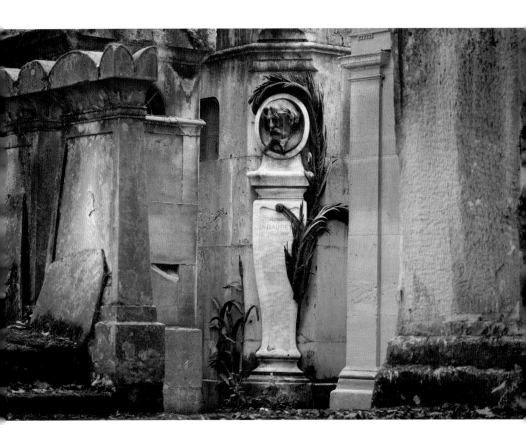

Molière and La Fontaine

I PREFER A PLEASANT VICE TO AN ANNOYING VIRTUE.

—Molière

DEATH NEVER TAKES THE WISE MAN BY SURPRISE; HE IS ALWAYS READY TO GO.

—Jean de La Fontaine

You will have noticed the increasingly steep topography of this section of Tour Two. The hilly landscape is also somewhat like a forest. Be careful as wet leaves and moss on top of cobblestones can make walking difficult. About forty paces to your right across Chemin Molière et La Fontaine into Division 25 are the burial places of writer Jean de La Fontaine (1621–1695) and actor and playwright Molière (Jean-Baptiste Poquelin) (1622–1673).

Though neither can claim Père-Lachaise as their original burial place, La Fontaine and Molière arrived here by way of Nicolas Frochot's brilliant bartering. When Napoléon challenged Frochot to attract the citizens of Paris to the idea of being buried in Père-Lachaise, the savvy master of PR went to work bringing famous remains to the site, including these two figures who were formerly interred at the St-Eustache church.

Honoré Daumier

Continue on Chemin Molière and La Fontaine take a right on the next path leading to Chemin La Place into Division 24. You will come to a large obelisk on your right, then across on your left you will find the tomb of artist, sculptor, and caricaturist Honoré Daumier (1808–1879).

Also a prolific printmaker said to have created five million artworks, Daumier was best known for his caricatures of political figures. Generally, King Louis-Philippe tolerated the artist's creative attacks, but once Daumier went too far, and the king sentenced him to six months in prison. "Paul Valéry, the distinguished French writer, noted that Daumier is often compared to Michelangelo and Rembrandt, observing that Michelangelo was the theologian of mankind, Rembrandt the philosopher, and Daumier the moralist. In the moralist's role, although Daumier can entertain us as we observe the daily scene, more importantly, through his unfailing tolerance and deep human understanding, he can instruct us."[9]

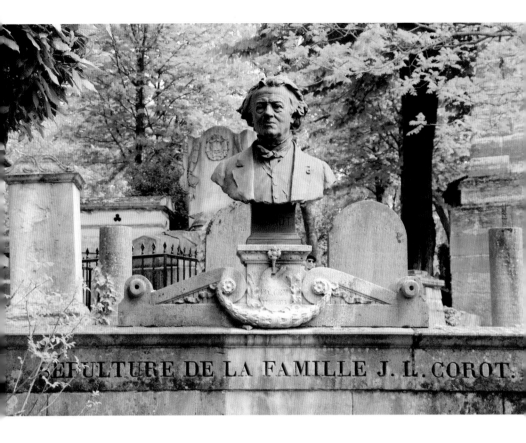

SEPULTURE DE LA FAMILLE J. L. COROT

Jean-Baptiste-Camille Corot

If you look a few yards beyond Daumier's tomb, you will see the back of a bronze head and shoulders marking your next destination, the gravesite that resembles a garden plot, dominated by a sculpture of artist and painter Jean-Baptiste-Camille Corot (1796–1875).

The bronze bust created by sculptor Michel Léonard Béguine (1855–1929) that sits atop the center stone marker with a palette and brush signifies Corot's role as a painter. A member of the French Barbizon School, Corot's work is highly recognizable by the dark-colored palette used in his landscapes. Recognition came slowly, but in 1845 the great poet Charles Baudelaire declared Corot the leader in the "modern school of landscape painting." In 1847, Eugène Delacroix (Division 49) noted in his journal, "Corot is a true artist. One has to see a painter in his own place to get an idea of his worth....Corot delves deeply into a subject: ideas come to him and he adds while working; it's the right approach."

In 1846, the French government decorated him with the cross of the Legion of Honor and in 1849 a position on the Salon Jury. This recognition greatly increased his popularity, which translated into sales and success. Corot was known for his compassion. When fellow artist Daumier was blind and homeless, he bought him a home in Auvers. He also gave money to the widow of the artist Jean-François Millet to support her children. Corot never married and died of a stomach disease in Paris.

RENÉ LALIQUE

Step back out into Chemin La Place and take a left to Chemin Adanson and enter Division 23, where you will find a grave of jeweler and glassmaker René Lalique (1860–1945).

A crucifix made in the artist's signature frosted glass is embedded on the tomb. During his long life, Lalique was the most celebrated jeweler in the world. He designed pieces of jewelry for French jewelers Cartier, Boucheron, and others. He applied his Art Deco styling to many *objets d'art*, including usable art glass. Not only an accomplished artist but an innovator, he leveraged his skills and industrial techniques during changing times, utilizing mass production for his artwork that brought art glass to a wide audience.

JEAN-AUGUSTE-DOMINIQUE INGRES

Walk for about thirty paces to the west end of Division 23, and you come to a tall monument with a bust in the niche commemorating artist Jean-Auguste-Dominique Ingres (1780–1867).

A member of the French Neoclassical School, Ingres worked in the studio of Jacques-Louis David (Division 56), the most celebrated artist of his day. In 1801 Ingres made his Salon debut and won the Prix de Rome for his painting *The Ambassadors of Agamemnon in the Tent of Achilles.* "Ingres was undoubtedly among the most experimental artists of the twentieth century. His constant search for the idealized human form, particularly in the female body, was the cause of his highly controversial anatomical

distortions. He made a habit of elongating backs, his nudes sometimes described by critics as "creatures not found in nature."[10] This treatment is most evident in his painting, *La Grande Odalisque*, in the collection of the Louvre.

Ingres died of pneumonia at the age of eighty-six in his apartment on the Quai Voltaire. The bust of the artist on the tomb was created by his student, sculptor Jean-Marie Bienaimé Bonnassieux (1810–1892).

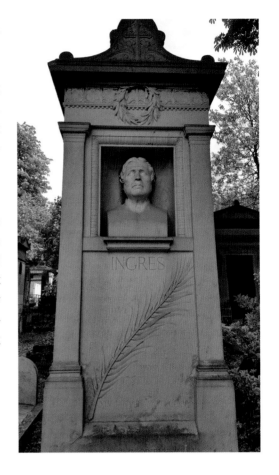

Eugène Delacroix

Do all the work you can; that is the whole philosophy of the good way of life.

—Eugène Delacroix

Turn up Avenue Saint-Morys to the Avenue Transversale No. 1 and walk left to Division 49 to Chemin Eugène Delacroix, and you arrive at the tomb of artist Eugène Delacroix (1798–1863).

A key figure in nineteenth-century Paris, he was considered the leader of the French Romantic school. Probably Delacroix's best-known painting, *Liberty Leading the People,* is an unforgettable image of Parisians having taken up arms, marching forward under the banner of the tricolor representing liberty, equality, and fraternity. The painting is in the collection of the Louvre.

The Doric frieze seen on the altar tomb of Lucius Cornelius Scipio Barbatus, a Roman consul in 298 B.C., became a very popular motif used on many nineteenth century tombs in Père-Lachaise. Delacroix saw a similar tomb in the Vatican and decided he wanted this kind of memorial and adopted the Scipian style altar tomb for his sarcophagus of black Volvic lava with his name inscribed in gold leaf. A low granite tomb just to the left as you face Delacroix, marks the resting place of his devoted housekeeper, Jeanne-Marie le Guillou, who guarded the artist's privacy and contributed to Delacroix's health, welfare, and long life.

ANTOINE LOUIS BARYE

Directly behind Delacroix and to the left is the final resting place of sculptor Antoine Louis Barye (1796–1875).

Barye was famous for his large- and small-scale bronze sculptures of animals. He and Delacroix were friends, and both enjoyed using animals as subjects in their artworks. Barye was regarded as one of the great animal life artists of the French school, and his works, including *Tiger Devouring a Gavial Crocodile* and *Lion Crushing a Serpent* are unforgettable. Unfortunately, the bronze portrait bust of the artist by sculptor Julien-Hippolyte Moulin (1832–1884) that sat in the small niche on Barye's tomb has disappeared.

GÉRARD DE NERVAL

Walking north across Division 49, facing Chemin Casimir Delavigne, you approach the column grave marker for poet Gérard de Nerval (1808–1855), the nom de plume of Gérard Labrunie.

A French Romantic poet, Nerval's themes and preoccupations were to greatly influence the Symbolists and Surrealists. Marcel Proust (Division 85, Tour 3) and Victor Hugo were great admirers of Nerval's work, which stressed the significance of dreams.

Debilitated by mental illness throughout his career, Nerval was institutionalized many times. He describes his obsessions and hallucinations in his work, including *Aurélia* (1853–54), a story recounting his memory of

actress Jenny Colon, with whom he fell in love, but she married another, then died years later.

His years of misery ended in 1855 when he was found hanging from a lamppost in the rue de la Vieille Lanterne, Paris.

Honoré de Balzac

Turn around to see the tomb of writer and novelist Honoré de Balzac (1799–1850).

Balzac's unforgettable masterpiece is *La Comédie Humaine.* He lived a full life. Five months before the end of his fifty-one years, he married his longtime mistress, the Countess Eve Hańska. Hańska, who made the funeral arrangements, commissioned sculptor David d'Angers to create the regal bronze bust of Balzac that rests atop a stone pillar. A bronze book with quill pen is placed at the base of the tomb. The location of his tomb is one of the highest points of the cemetery and commands a splendid view of Paris.

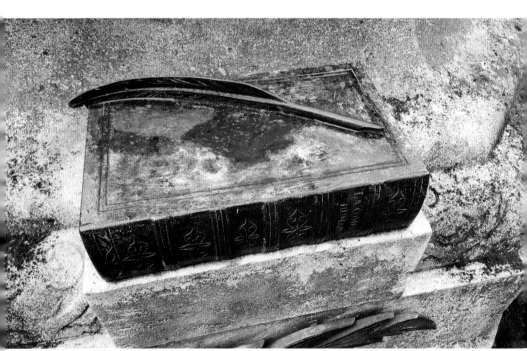

ABOVE: A BRONZE VOLUME OF BALZAC'S LA COMÉDIE HUMAINE.

Gustave Caillebotte

Heading west around the nearby circle and taking the Avenue des Ailantes down to Division 70, about two-thirds of the way on your right, you find the chapel-style tomb of artist and painter Gustave Caillebotte (1848–1894).

Caillebotte was born into a wealthy family and, though he enjoyed drawing and painting as a young man, he pursued a law degree and was also trained as an engineer. Following his service in the Franco-Prussian War, he began his life as an artist in earnest, enrolling in the École des Beaux-Arts in 1873.

He was strongly influenced by his Impressionist associates, including Edgar Degas, and made his debut in 1877 in the second of eight exhibitions of the Impressionists. At the third exhibition in 1876, he exhibited one of his best known works, *The Floor Scrapers* (1875).

Not unlike a fellow artist with means, Camille Corot (Division 24), Caillebotte played a pivotal role as a patron, including supporting artists such as Monet, Renoir, and Pissarro (Division 7, Tour One). While working in his garden one day, he suffered a severe stroke and died at age forty-five.

Georges Enesco

Heading south west on Avenue des Ailantes, toward the intersection of Avenue de la Chapelle on the right at the corner you come to the low, cream-colored tomb of violinist, composer, and conductor Georges Enesco, also known as George Enescu (1881–1955).

A preeminent Romanian musician of the twentieth century, Enesco is considered one of the greatest performers of his time. Highly influenced by Romanian folk music, he was also a noted teacher, and among his students was Yehudi Menuhin. He studied in Paris, where his "Poème roumain" was played, and later won first prize for violin at the Paris Conservatory. As a virtuoso violinist, he became widely known for his interpretations of Bach. Pablo Casals described Enescu as "the greatest musical phenomenon since Mozart" and "one of the greatest geniuses of modern music."

Georges Bizet

As a musician I tell you that if you were to suppress adultery, fanaticism, crime, evil, the supernatural, there would no longer be the means for writing one note.

—Georges Bizet

Six tombs down from Enesco on your left in Division 68 is pianist and composer Georges Bizet (1838–1875).

A Frenchman of the Romantic period, he is best known for one of the world's best-loved operas, *Carmen.* The tomb was previously marked with a bronze bust (pictured here) created by sculptor Paul Dubois (Division 7, Tour One), which has been stolen and recovered and is now kept in storage.

As a pianist, Bizet showed great talent from an early age. Unfortunately, that skill was cut short when he died at thirty-six. At his funeral at the Église de la Sainte-Trinité in Montmartre, more than 4,000 people were present. An orchestra under Pasdeloup played Patrie, and the organist improvised a fantasy on themes from *Carmen.*

Raymond Radiguet

Walk across to Avenue des Ailantes after Enesco, at bottom of the stairs, tucked behind first row of tombs on the left in Division 56 is the grave of writer Raymond Radiguet (1903–1923).

Radiguet came to Paris to pursue his passions for journalism and literature. He quickly made friends with the Modernists of the day, including Picasso, Max Jacob, and Juan Gris. He was also very close to Jean Cocteau, who became his mentor as well as lover. In 1923, he published his first and most famous novel, *Le Diable au corps* (*The Devil in the Flesh*). That same year, he died of typhoid.

A

GEORGES BIZET

SA FAMILLE

ET SES AMIS

Georges Seurat

Take a right on Avenue des Peupliers, with Division 66 on your left. Walk midway down this path, and on your left, partially hidden by a tree, you come upon the burial site of artist and painter Georges Seurat (1859–1891).

Seurat is best known for *A Sunday Afternoon on the Island of La Grande Jatte* (1884). The large-scale artwork employs Seurat's trademark technique of pointillism. He is considered an icon of nineteenth-century painting and changed the direction of modern art by initiating Neo-impressionism. Composer and Broadway producer Stephen Sondheim created *Sunday in the Park with George* based on this painting.

Jean de Brunhoff

Across from Seurat's tomb and Avenue des Peupliers there is an unnamed walkway that leads to the grave of writer and illustrator Jean de Brunhoff (1899–1937) on the right.

Best known for creating the seven Babar books, Brunhoff died at age thirty-seven. The tales of a little elephant who leaves the jungle for a city resembling Paris have continued for decades to captivate young and old alike as favorite bedtime stories.

Georges Méliès

Walk out to the main road, Avenue Circulaire, and take a left. There is a small path a few paces on your right—take that, and behind the first row of chapel-style tombs on your left in Division 64 you find legendary filmmaker George Méliès (1861–1938).

Atop the gravestone, you will find a bronze bust of the mustache-and-goatee-wearing filmmaker created by sculptor Renato Carvillani. Méliès created many film firsts, including double exposures, the first split screen with performers acting opposite themselves, and the first dissolve. He produced over 500 films and was presented the Legion of Honor from the French government. Méliès's career was reignited in director Martin Scorsese's award-winning film *Hugo*, starring Ben Kingsley as the

remarkable magician and illusionist who became one of cinema's earliest and most innovative directors.

Walk back to the main cobbled path of Avenue Circulaire, then head downhill on Avenue de l'Ouest toward the Northwest side door entrance and exit onto Boulevard de Ménilmontant across from the Père-Lachaise Metro stop. This is the most challenging tour in that it traverses the highest elevation, as well as the entire width of the cemetery. Chronologically, you have visited over two hundred years of iconic cultural legends.

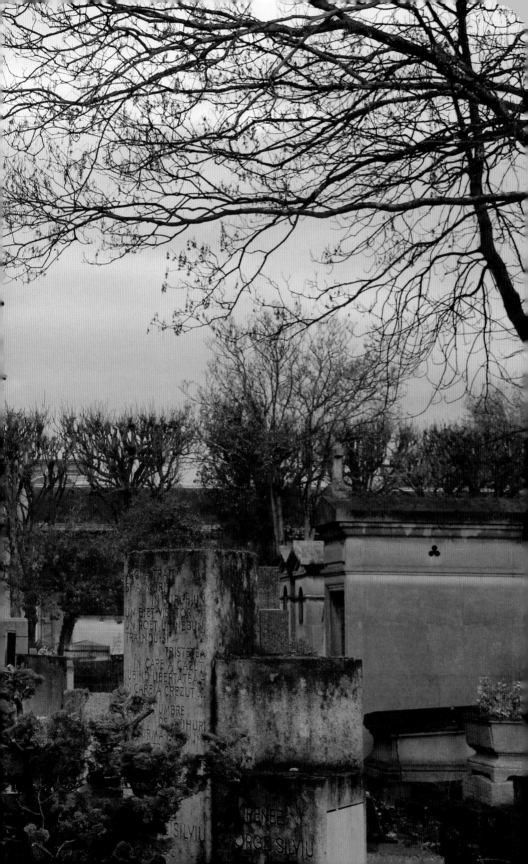

Tour Three

Tour Three, with the closest entry gate near Avenue Gambetta, starts out on level ground, then slopes to allow you to walk downhill through the ages. The tour covers the northeastern section of the cemetery and features the Columbarium, where the ashes of thousands of people are interred.

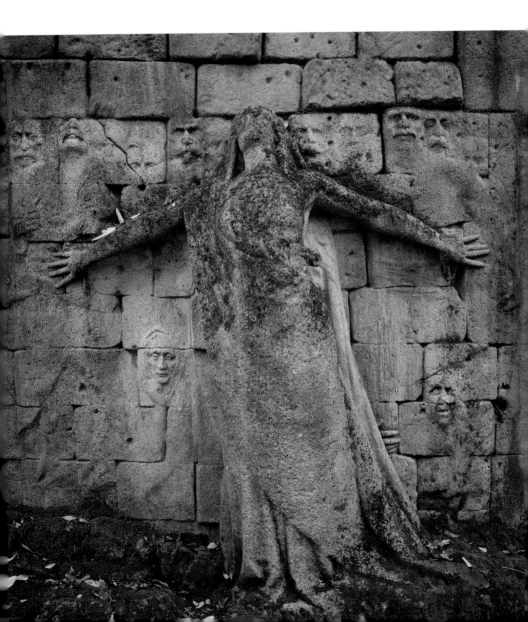

Memorial Sculpture by Paul Moreau-Vauthier

There is a fascinating artwork that you may wish to see before taking Tour Three. Instead of riding the Metro and getting off at the Gambetta stop, you may prefer to walk from the Père-Lachaise Metro stop into the public park, Square Samuel de Champlain, which is only about 100 feet (30 meters) up Avenue Gambetta on your right. The park runs along the northern wall of Père-Lachaise, parallel with Gambetta.

Midway up a steep incline in the park, you will find a dramatic and moving sculpture by Moreau-Vauthier (1871–1936), who is buried in Division 14. The sculpture depicts the final moments of 147 communards lined up against the *mur des Fédérés* (Communards' Wall). (The real wall is in Division 76.) After being summarily executed, their bodies were dumped into a mass grave directly in front of the wall. In this artwork, a robed female figure with arms outstretched is surrounded by the ghostlike figures of the fallen communards.

The Association of the Friends of the Paris Commune has long explained that the much-photographed bas-relief sculpture is not the famous Communards' Wall—nor is it accepted as a symbol of remembrance for the commune members who fell. In consulting a colleague and cemetery historian, Steve Soper, he thought that the idea was to include this sculpture in Division 76, but too many political issues were at stake, so it was eventually placed outside and out of the way—where it could do little harm to any one group or organization.

Porte Gambetta Entrance

This entrance brings visitors to Père-Lachaise from the northeast gate near Place de la Gambetta.

Restrooms

To the far right as you enter the cemetery is a stone building with restrooms.

Harriet Toby

As you step through the cemetery entryway from Avenue Gambetta, walk up a short flight of stairs in an area bounded by hedges in Division 88, you then come upon the grave of actress and dancer Harriet Toby (1929–1952).

The bas relief of the dancer as a lithe-figured ballerina is *en pointe* on a tall granite monument. As an actress, Toby played the role of Tania in *La Belle que voilà (Here Is the Beauty)*, a 1950 French dramatic film directed by Jean-Paul Le Chanois. She performed for the Grand Ballet Du Marquis De Cuevas in a production at the Cambridge Theatre in London with Rosella Hightower, George Skibine, Marjorie Tallchief, George Zoritch, and Serge Golovine also in the cast. Toby and thirty six others were killed in a plane crash when their flight from Nice, France ran into a flock of migratory birds.

Marie Laurencin

Follow the path on your left to find artist Marie Laurencin (1883–1956) on your right. If you come to Avenue Aguado you have gone too far. The grave is somewhat hard to find, so look for a small tree in a planter that is part of her low-lying, flat granite tomb.

Laurencin was an important figure in the Parisian avant-garde that included Pablo Picasso and Georges Braque. Braque introduced her to Picasso's circle, where she met the poet, art critic, and promoter Guillaume Apollinaire (Division 86), who became her lover. She also became his muse, and he, in turn, championed her paintings and prints featuring women and animals. Laurencin continued to explore themes of femininity until her death.

Jardin du Souvenir (Garden of Remembrance)

Along the entire interior perimeter wall on Avenue Circulaire there is a green space abutting it that is called the Jardin du Souvenir (Garden of Remembrance) in Division 77.

There are two headstones marking the gardens along Avenue Circulaire. The ashes of those who have requested burial here nourish the rose beds and other plantings in this narrow parcel of land. As this is a far more affordable—and thus popular—resting place than the formal burial plots, permission to be spread in the garden must be granted through the cemetery offices. Remains are picked up at the Crematorium, followed by a funeral ceremony at the site.

OSCAR WILDE

DEATH MUST BE SO BEAUTIFUL. TO LIE IN THE SOFT BROWN EARTH, WITH THE GRASSES WAVING ABOVE ONE'S HEAD, AND LISTEN TO SILENCE. TO HAVE NO YESTERDAY, AND NO TOMORROW. TO FORGET TIME, TO FORGIVE LIFE, TO BE AT PEACE.

—OSCAR WILDE

Walk out to Avenue Circulaire, turn right on Avenue Carette, and take another right into Division 89 to reach the tomb of brilliant essayist, eminent playwright, poet, and society wit Oscar Wilde (1854–1900).

Among Wilde's many notable works are *The Importance of Being Earnest*, *The Picture of Dorian Gray*, *Lady Windermere's Fan*, *A Woman of No Importance*, and *An Ideal Husband*. On November 30, 1900, at two o'clock in the afternoon, Oscar Wilde died of an infection to his inner ear with the added complication of cerebral meningitis (the result of an injury sustained while serving a two-year sentence in Reading prison for his legendary homosexual affair with Lord Alfred "Bosie" Douglas). He died in a rented room that had been his home since 1898, in the Hôtel d'Alsace, 13 rue des Beaux-Arts in Paris. Wilde is interred with his longtime friend, executor of his estate, and first lover Robert Ross.

Robert Planquette

As you walk down Avenue Carette toward the intersection of Avenue Transversale No. 3, on your left you find the elaborate tomb of French composer of songs and operettas Robert Planquette (1848–1903).

The tomb features a pair of griffins at the base. The portrait medallion in the center of the tomb was created by sculptor Julien-Prosper Legastelois. After studying at the Paris Conservatoire, Planquette played

 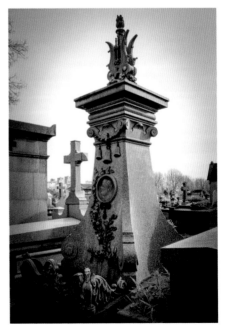

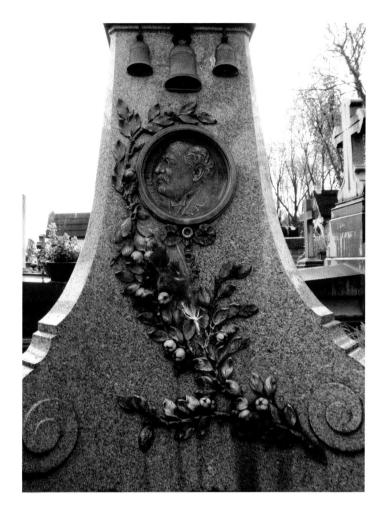

and wrote songs for café concerts (cafés offering light music). Several of his operettas were extraordinarily successful in Britain, including *Les Cloches de Corneville (The Bells of Corneville, 1877–8)*. The three bronze bas-relief bells on his tomb are a reference to this smash hit; the length of its initial London run broke all records for any piece of musical theatre up to that time. It received over 1,200 performances in Paris and London and remains a staple of the light opera repertory. This work and *Rip Van Winkle* (1882), earned Planquette international fame. A street in the eighteenth arrondissement is named for him.

Gertrude Stein and Alice B. Toklas

Argument is to me the air I breathe. Given any proposition, I cannot help believing the other side and defending it.

—Gertrude Stein

Walk east and take a left at Avenue Greffulhe and a right at Avenue Circulaire to Division 94, where on the right you come upon the burial place of poet, novelist, and critic Gertrude Stein (1874–1946) and Alice B. Toklas, writer (1877–1967).

Don't be thrown off by the incorrect date on Stein's tomb (1947), the misspelling of her birthplace (Allfghany, Pennsylvania), or the absence of Alice's name. Stein passed in 1946, was born in Allegheny, and her loving companion Alice's name appears on the back of the low granite headstone. You may find small pebbles left on her tomb as symbols of remembrance, a Jewish tradition that is repeated on several gravesites in this area.

With Gertrude for thirty-nine years, Alice enjoyed the more domestic role in the relationship and handled the bill-paying, shopping, and cooking, as well as clerical duties such as typing Gertrude's manuscripts. Gertrude played the grand host. Their apartment at 27 rue de Fleurus was considered one of the most influential and important salons in Paris. Stein loathed doctors, and her long-ignored problems with colitis led to stomach cancer. She died on the operating table at the American Hospital in Paris. Twenty-one years later, Toklas requested that her name be on the back of the tomb, always in the shadow of her life partner.

Holocaust Memorials

Another exception to my focus on the creative spirits of Père-Lachaise is the inclusion of this area along Avenue Circulaire of several Holocaust Memorials in Divisions 77, 76, and 97 with monumental sculptures dedicated to those who lost their lives in concentration camps, including Bergen-Belsen, Dachau, and Auschwitz. Doubtless, many were artists, writers, and musicians.

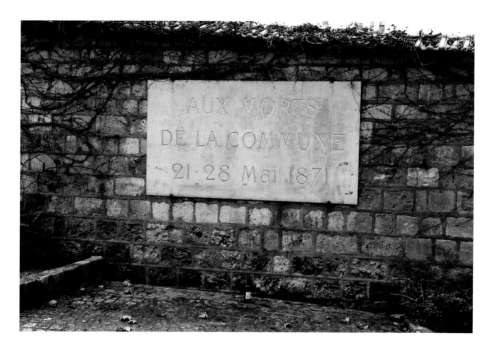

The Communards' Wall

Another important memorial, found at the far wall in Division 76, is the Communards' Wall (*mur des Fédérés*).

On May 28, 1871, one-hundred-forty-seven *fédérés* (combatants of the Paris Commune), were executed and buried in a mass grave at the foot of the wall. French Leftists, socialists, and communists in particular, see the wall as a symbol of the people's struggle for their liberty and ideals.

Paul Éluard

Midway on your right in Division 97, you come upon the modest gravesite of Paul Éluard, poet and writer (1895–1952).

Considered a leading twentieth-century poet in France, he was a founder of Surrealism. Among his friends were André Breton, Louis Aragon, Man Ray, and Max Ernst (Division 87); the latter became inextricably linked to Éluard's creativity and love life. Éluard, with his Russian wife Gala, saw an exhibition of Ernst's work and later arranged to meet him in the Alps. They became inseparable and engaged in a ménage a trois for three years.

During his involvement with the French Resistance, Éluard wrote *Liberty* (1942), but when his political writings turned to supporting Stalin, he was alienated from his surrealist friends. A collection of poems, which Éluard described as his last, was titled *Mourir de ne pas Mourir (Dying of Not Dying, 1924)*, and the frontispiece was a portrait of Éluard by Ernst. Éluard suffered from bouts of tuberculosis throughout his life and he died following a final recurrence of the disease at the age of fifty-seven.

Gerda Taro

As a landmark, look for the two large hands carved in light stone at the Ravensbrück Memorial down from Paul Eluard's grave. You are still in Division 97. Take the first right up a set of stairs and another right into the first small alley; four tombs in, you arrive at the grave of photojournalist Gerta Pohorylle (1910–1937), known professionally as Gerda Taro.

Taro was a German Jewish war photographer during the Spanish Civil War and is regarded as the first woman photojournalist to have died while covering the front line. Taro's lover, colleague, and fellow war photographer, Robert Capa, also used a

pseudonym (his real name was Endre Friedmann). Their aliases helped them tap into the lucrative American market. Many images credited as Capa's work were actually Taro's.

While covering the Battle of Brunete in Spain, she hopped on the footboard of an emergency vehicle transporting the wounded. A Republican tank crashed into its side, and Taro suffered critical wounds, dying the following day.

EDITH PIAF

YOUR VOICE IS THE SOUL OF PARIS.
 —MARLENE DIETRICH, TO PIAF

Continue following Avenue Circulaire and turn right onto Avenue Transversale No. 3. On the right is the tomb of the Famille Gassion, containing the celebrated chanteuse, actor, and singer Edith Piaf (1915–1963).

At age nineteen, Piaf was discovered in the Pigalle area of Paris by nightclub owner Louis Leplée, who was inspired to give the petite (she stood 142 centimeters—4 feet 10 inches), and nervous young singer her stage name, *La Môme Piaf* (Paris slang meaning *The Waif Sparrow* or *The Little Sparrow*).

Although she was denied a funeral mass by Cardinal Maurice Feltin because of her drug and alcohol abuse and several divorces, her funeral procession drew tens of thousands of mourners onto the streets of Paris, and the ceremony at the cemetery was attended by more than 100,000 fans.

She is interred in a low, dark gray tomb along with her father Philippe Gassion and the last of her husbands, the young Greek Théo Sarapo (Theophanis Lamboukas), and her daughter Marcelle, fathered by Louis Dupont.

On the feast of All Souls' Day, Piaf's tomb is one of the most highly visited in the cemetery, and the heaps of floral bouquets reflect the passion her fans still carry for one of the greatest performers of all time.

AMEDEO MODIGLIANI AND JEANNE HÉBUTERNE

As you step across the avenue diagonally to Division 96, pass four trees and see a small bush, where on the other side, there is a low granite slab marking the resting place of painter and sculptor Amedeo "Modi" Modigliani (1884–1920) and the artist and his muse Jeanne Hébuterne (1898–1920).

Modigliani was born in Livorno, Italy, and is known for portraits and nudes in a modern style characterized by elongation of faces and figures. He spent most of his creative life as a painter and sculptor, in Paris, France and was part of a Bohemian circle with artists such as Pablo Picasso and Constantin Brâncuși. Though his work was not received well during his lifetime, he did exhibit his work, including highly stylized sculptures with Cubists of the Section d'Or group at the Salon d'Automne.

Sculptor Moïse Kisling made Modigliani's funeral arrangements. The funeral was impressive. All Paris came to Père-Lachaise to see Modigliani off—in stark contrast to the pathetic treatment given to Jeanne. Her family, totally ashamed by what they deemed her scandalous relationship with Modi, refused his friends' request to have a double funeral; instead, they took her to the outskirts of the city to Bagneaux cemetery.

Jeanne was best known as the frequent model and common-law wife of Modigliani. A beauty, she was introduced to the artistic community in Montparnasse by her brother André, who wanted to become a painter. She studied at the Académie Colarossi. It was there in the spring of 1917 that Jeanne was introduced to Modigliani by the sculptor Chana Orloff, who along with many other artists came to sketch the academy's live models. Jeanne began an affair with Modi, and the two fell deeply in love. She soon moved in with him, despite strong objection from her parents.

Jeanne's family brought their daughter to their home after hearing that Modigliani had died, but the distraught Jeanne threw herself out of the fifth-floor apartment window, killing herself and her unborn child. Nearly a decade later, the family allowed her remains to be transferred to Père-Lachaise to rest beside Modigliani. Her epitaph reads: "Devoted companion to the extreme sacrifice."

This is another entrance that brings visitors to Avenue Transversale No. 2. The stairs are steep, and they are adjacent to a small public park in the neighborhood.

ANDRÉ GILL

Stepping back out onto Avenue Transversale No. 3, take a left on Avenue Pacthod, a right on Avenue Transversale No. 2, then on your right you come to caricaturist André Gill (1840–1885).

Gill, noted for creating lithographic portraits recognizable for their oversized heads and tiny bodies, was widely published throughout his career. He drew portraits of the major personalities of his day, including Sarah Bernhardt (Division 44), Charles Dickens, Richard Wagner, and Émile Zola. Many enjoyed his artwork, but a few did not, including Napoléon III, who had Gill's portrait of him censored.

Other disgruntled subjects of his portraits filed lawsuits, which in some cases brought the artist only more notoriety. Toward the end of his illustrious career, he succumbed to mental illness and died in an asylum. Paris celebrates his memory with a bust of the artist on Rue André Gill in Montmartre. The bust on the tomb was created by sculptor Laure Coutan.

Victor Noir

Continue on Avenue Transversale No. 2 and on your right you arrive at Division 92. You may find people gathered around the prone figure of journalist Victor Noir (1848–1870).

Noir was shot to death by Napoléon III's cousin Pierre Bonaparte, who took offense with criticism published in the press by Noir's editor Paschal Grousset. Noir was asked to be his editor's second in a duel and was shot by Bonaparte during a confrontation.

The bronze figure commemorates Noir's murder, his top hat at his feet after as he has fallen to the ground. The tomb was designed by the distinguished sculptor Jules Dalou. You will notice that, in stark contrast to the overall blue oxidized patina of the sculpture, one portion of Noir's anatomy is polished. This is the result of a long tradition of young women wanting to get pregnant by rubbing his genital area for good luck. This tradition seems to have to do with the sculpture itself rather than any story about Noir's virility.

Sarah Bernhardt

Continuing along Avenue Transversale No. 2 and turning left onto Avenue Carette past Division 91 and left again in a dogleg turn on a narrow dirt path into Division 44, you meet the Divine Sarah, actress Sarah Bernhardt (1844–1923). You must peer between two bushes that have seen grown to see her tomb.

As a young actress, she was student at the Comédie-Française, and went on to perform throughout Europe and the United States, becoming one of the nineteenth century's most celebrated thespians.

Bernhardt designed her own burial place in Père-Lachaise, which features a small granite casket seen through four arches of a tomb four feet high. Her funeral was an extravaganza, with beautiful horses drawing a polished lacquer carriage decorated with black ostrich plumes. The respectful funeral procession stretched for blocks in all directions, and the crowds left massive tributes of fragrant red roses for France's leading lady of the theater.

SIMONE SIGNORET AND YVES MONTAND

Walking diagonally north through this division, crossing onto Avenue Aguado, you will see the dome of the Crematorium nearby in the distance and up farther on your left is a wide cobblestone pathway. On your left and near a large chapel-style tomb, you come to the burial place of actress Simone Signoret (1921–1985) and her husband—actor and singer Yves Montand (1921–1991).

The gravesite is marked by a low-slung, plain granite headstone with their names incised on the front. One of France's most revered movie stars, Signoret was the first French actress to receive a best actress Oscar for her English-speaking role in the *Room at the Top* (1959). Though she was often wooed by Hollywood, she chose to work mainly in Europe.

Montand was discovered by Edith Piaf, who took the Italian-born singer under her wing as well as her bed covers. His songs about Paris became classics. Montand also costarred with his wife in several films and was a success on Broadway.

GUILLAUME APOLLINAIRE

"COME TO THE EDGE," HE SAID.

"WE CAN'T, WE'RE AFRAID!" THEY RESPONDED.

"COME TO THE EDGE," HE SAID.

"WE CAN'T, WE WILL FALL!" THEY RESPONDED.

"COME TO THE EDGE," HE SAID.

AND SO THEY CAME.

AND HE PUSHED THEM.

AND THEY FLEW.

—GUILLAUME APOLLINAIRE

Move back to your left onto Avenue Transversale No. 2, and, walking north, take a left turn on Avenue des Combattants Étrangers into Division 86. On your right, among a cluster of tombs, is the tall stone marker noting the resting place of poet, novelist, dramatist, and art critic Guillaume Apollinaire (1880–1918).

Buried along with his wife Jacqueline Kolb, Apollinaire died of influenza at the age of thirty-eight after only a few months of marriage.

The headstone is in the shape of a freeform stele. The lower slab of his tomb is inscribed with one of his classic calligrams, or poems in the shape of an image—in this case a heart. It reads, "My heart is like an everlasting flame." A champion of the avant-garde in early twentieth-century Paris, he is believed to have coined the term *surrealist*. He was a consummate wordsmith, but not everyone was fond of his critical writing. However, many, including his close friend Pablo Picasso, agreed that he was a tireless promoter of Cubism, which was under constant attack by the establishment. Apollinaire saw his role as the herald of the great art of the new century.

As a war hero who fought and was injured in World War I, he was awarded the Croix de Guerre and received full military honors at his death. His funeral services were attended by a who's who of the era, including Andre Breton, Jean Cocteau, and Raymond Radiguet—the latter two read their poems. His memory is further acknowledged by naming the street behind the famed Café des Deux Magots, Rue Guillaume Apollinaire.

Marcel Proust

Happiness is beneficial for the body, but it is grief that develops the powers of the mind.

—Marcel Proust

Stepping back onto the Avenue des Étrangers and taking a left onto Avenue Transversale No. 2, you come to a small alleyway in the center of Division 85. Only a small corner of a low tomb appears on the other side of a tall chapel-style crypt. However, there is no mistaking the sleek, black marble tomb of writer Marcel Proust (1871–1922).

The tomb is covered with small stones (a symbol for those on a journey) along with notes, and many times—a fairly new tradition—pens and pencils. Proust is buried along with his mother, father, and brother.

A child of a bourgeois family, as an adult Proust drew on Parisian fashionable society as the subject matter for his writing. Due to a lifelong yearning to be part of the aristocratic class, he voraciously observed the behaviors of people at leading salons, where he sported a Cartier tie pin and wore a signature orchid on his lapel. He was a master of analogies and metaphors, and focused on the themes of love and egoism and a preoccupation with time and death. A study in contrasts, he sometimes created ostensibly heterosexual lead characters that were either bisexual or came out as gay. He himself wrestled with his identity and lived in fear that his own homosexuality would adversely affect the public's acceptance of his work.

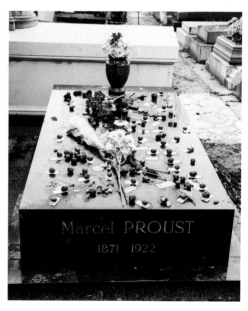

SADEGH - HEDAYAT
1903 - 1951

A recluse, he rarely left his apartment. He spent the last years of his life working on his masterpiece, arguably the greatest novel of the twentieth century, the sixteen-volume *À la recherche du temps perdu* (originally translated as *Remembrance of Things Past*, but more accurately as *In Search of Lost Time*). Ultimately, he worked himself to death, succumbing to pneumonia and dying in his brother's arms.

SĀDEGH HEDĀYAT

Moving diagonally northeast from Proust's tomb you'll enter an area within a wall of hedges. Originally the burial place designated for Muslims, there was once a small mosque built on the site. It now has tombs of people representing all faiths. On the right is Iranian writer Sādegh Hedāyat (1903–1951).

Iran's foremost modern writer, Hedāyat never identified as Muslim but instead said he was a Persian and a communist. He studied for many years in Europe and is credited with helping to bring modern Persian literature to the attention of an international audience.

He wrote collections of short stories and a novella, *The Blind Owl*, which contains Hindu and Buddhist imagery, and is regarded as Hedayat's

masterpiece. The book was praised by many, including Henry Miller and André Breton. However, he also brought on himself the wrath of the Iranian clergy for his satirical attacks on their hypocrisy and greed.

"Another theme which attracted Hedāyat was the status of women in a male-dominated, traditional society like Iran. The best example how he dealt with this subject is a short story entitled 'Story with a Moral,' which was written in the form of Hekayat [romances]."[11]

After leaving Iran all but ostracized, Hedāyat found himself unable to find employment in France, and he committed suicide at age forty-eight. His burial place is marked by a low, black, highly polished pyramid inscribed with Arabic calligraphy spelling out his name. Note the image of an owl on the lower left side of the tomb in tribute to his book.

ABOVE: THE COLUMBARIUM.

Columbarium

Head east and cross over the Avenue des Combattants Étrangers and step into Division 87, another high point in the cemetery and the location of the grand Neo-Byzantine style Columbarium (Crematorium).

Built in 1894 and designed by Jean-Camille Formigé, the name comes from *columba* (Latin for *dove*) and originally referred to compartmentalized housing for doves and pigeons. On some days, a plume of smoke spirals up from the chimney, signaling the operation of its crematorium. To have one's ashes placed in the Columbarium, one can choose an underground vault or a niche for small urns in the two-tiered loggia outdoors.

Columbarium Stairs

To access burial niches on the upper tier, use these stairs.

Max Ophüls

In the far right corner as you enter the complex, take the stairs to the second tier and look closely for the number 6219 printed above the niche for film director Maximillian Oppenheimer (Max Ophüls) (1902–1957).

Born in Germany, as a young Jewish man and budding filmmaker he took the theatrical name of Max Ophüls. He fled to France to escape the Nazis and later went to the United States to continue making movies. His first Hollywood film, *The Exile* (1947), starred Douglas Fairbanks, Jr., followed by the highly acclaimed *Wild Calendar* (original title *Caught*, 1949). In the 1950s, he returned to Europe, where he remained until his death from rheumatic heart disease. He made over thirty films during his lifetime, including *La Ronde* (1950), which won the 1951 BAFTA (British Academy of Film and Television Arts) Award for Best Film.

Isadora Duncan

Farther ahead in this upper tier, in niche number 6796, is dancer and choreographer Isadora Duncan (1877–1927).

Born in San Francisco, she was the quintessential California free spirit. She made her professional debut in Chicago but spent most of her career performing her improvisational, modern style of movement in Europe, giving solo recitals or dancing with groups of children she had trained (she founded three schools). She was strongly influenced by mythology and always favored a signature diaphanous Greek-style tunic when she danced. Among her many admirers and friends were Oscar Wilde (Division 89), Auguste Rodin, Robert Henri, Ruth St. Denis, Gabriele D'Annunzio, and the young filmmaker Preston Sturges. Unfortunately, none of her work was ever documented on film.

The great Ballet Russes choreographer Mikhail Fokine said in his memoirs that she was the greatest American gift to the art of dance. With her many successes also came many defeats. Almost penniless by age forty-nine, she gave her final performance in Paris in 1927 and died that September in Nice in an auto accident. While riding in a sports car with a young mechanic, her long scarf caught in the spokes of the rear wheel, and she died instantly from a broken neck. According to her wishes, her body was taken to Paris and cremated; 4,000 people attended her memorial.

Richard Wright

Make your way back down to the ground level and walk farther along this section and toward the corner of the Columbarium near the front of

the staircase. You'll find a polished black marker on the bottom row, number 848, the burial place of writer Richard Wright (1908–1960).

Born on a Mississippi plantation, this distinguished African American author was featured on a US postage stamp in 2009. In his 1945 bestselling autobiography *Black Boy*, Wright acknowledged other writers who influenced him, including Gertrude Stein (Division 94), Marcel Proust (Division 85), H.L. Mencken, and Sinclair Lewis. A subsequent printing in 1991 included the section *American Hunger*, previously excluded from his original manuscript. He moved to Paris in 1946 and became a French citizen in 1947. He counted among his friends Jean-Paul Sartre and Albert Camus as well as his fellow expatriates Chester Himes and James Baldwin. His works dealt with the profound insights and aspirations of the oppressed such as poverty, anger, and the injustices toward northern and southern black Americans. In 1959, he began writing haiku and completed 4,000 pieces before his death of a heart attack at age fifty-two.

MAX ERNST

Turning the corner, take a left, and little more than halfway down this aisle near the foot of the stairs you come to the modest and not-so-easy-to-find wall plaque number 2102, where you'll find artist Max Ernst (1891–1976).

Born in Germany, this prolific creator of paintings, sculptures, graphics, and poetry is considered one of the early pioneers of the Dada and Surrealist movements. His artworks reflect a mining of folklore and mythology involving animals (his alter ego in paintings was a bird called Loplop) as well as images of biomorphic and imagined beings. The vivid imagery evident in his artwork was surpassed only by the surreal pattern of his love life. Leaving his first wife and child behind, he entered into a three-year menage à trois with the poet Paul Éluard (Division 97) and his wife Gala. After Gala left the relationship to be with Salvador Dali, Ernst caused a scandal by running off with a teenager from a convent. He later lived with the English painter Leonora Carrington, leaving her behind when he fled Vichy France for New York to marry his patron, the American collector Peggy Guggenheim. He married his fourth and final wife, the celebrated American painter and poet Dorothea Tanning; they

were married in a double ceremony in Beverly Hills with Man Ray and Juliet Browner. Ernst died in Paris a French citizen.

Paul Dukas

Walking to the far left, outside north corner of the Columbarium, taking the stairs to the upper wall, you come to niche number 4938, composer Paul Dukas (1865–1935).

One of the composer's most popular works, *L'Apprenti sorcier* (*The Sorcerer's Apprentice*, 1897), was made famous in the 1940 animated film *Fantasia*, produced by Walt Disney. The movie's audiences heard the film's classical music conducted by Leopold Stokowski in in stereophonic sound, a first for a commercial film.

He did not earn a living by composing alone, so Dukas also worked as a music critic, and later in life taught at the Conservatoire de Paris and the École Normale de Musique de Paris. Among his pupils was Olivier Messiaen. He was quoted as saying to one of his students, "Always remember that music should be written from the heart and not with the head." In the last year of his life, Dukas was elected to membership of the Académie des Beaux-Arts.

Lower Columbarium Entrance

In order to locate the final destination on your visit in the Columbarium, the burial niche of Maria Callas, you must backtrack to where you started and go down the wide stairs to the lower level.

Maria Callas

Head toward the main entrance to the Columbarium area where you first arrived; stepping inside the inner courtyard and down the wide staircase, you come to chamber number 16258 on aisle J, opera diva Maria Callas (1923–1977).

More than 300 books have been written about this American-born Greek dramatic soprano. Callas made her official debut at La Scala in Milan, Italy, performing in Giuseppe Verdi's *I vespri siciliani* in 1951. In 1952, she made her London debut at the Royal Opera House in *Norma*, and several years later she made her Metropolitan Opera debut in New York City, opening the Met's seventy-second season in 1956, again with *Norma*.

Callas spent her last years living largely in isolation in Paris, and it was suspected that she died of a heart attack (there was no autopsy). A funerary mass was held at St. Stephen's Greek Orthodox Cathedral on Rue Georges-Bizet. The opera singer's ashes were originally buried in the Columbarium. After their theft and subsequent recovery, they were scattered into the Aegean Sea, off the coast of Greece. The empty urn remains in Père-Lachaise. Her influence has been so enduring that in 2006, *Opera News* wrote of her, "Nearly thirty years after her death, she's still the definition of the diva as artist, and still one of classical music's best-selling vocalists." In 2007, Callas was posthumously awarded the Grammy Lifetime Achievement Award. In the same year, she was voted the greatest soprano of all time by *BBC Music Magazine*.

Heading back up the stairs and outside, walk straight ahead out onto Avenue des Étrangers and toward the cemetery's Avenue Gambetta exit. Prepare yourself for reentry into the urban bustle of the living Paris. However, Père-Lachaise always beckons you back.

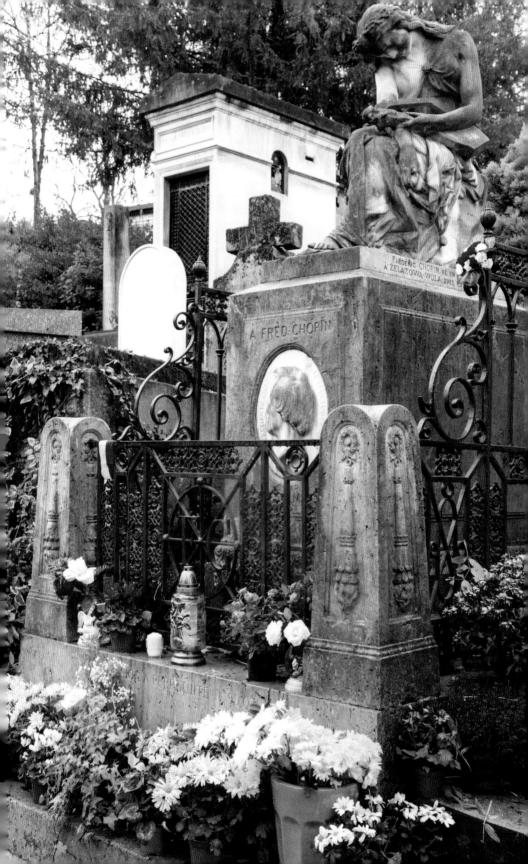

CHAPTER FIVE

CAN ETERNITY LAST FOREVER?

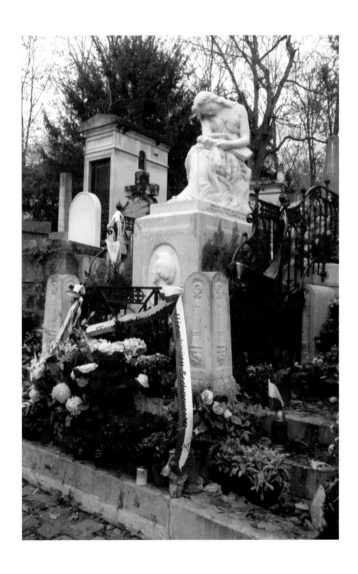

With the cemetery's popularity attracting millions of visitors, plus the ravages of time, the impact on the abundant, crowded monuments is that they are fast sinking into the earth, with sometimes only a marble corner visible above an elegant mulch of dried-up bouquets. Headstones have fallen over and shattered. The effect is melancholy, dense, and dark.

Walking through the cemetery, you can see tombs that seem well-tended and others that are totally engulfed by vines, streaked with dark stains from air pollution. The cemetery no longer uses pesticides, so insects and plants reign supreme. Lichen and moss grow back in only a year even after tombs are cleaned. Personally, I find that the apparent ruins create an atmosphere that inspires me; the power of nature taking over where humankind no longer is in control, though the damage can be alarming where cultural history is at risk.

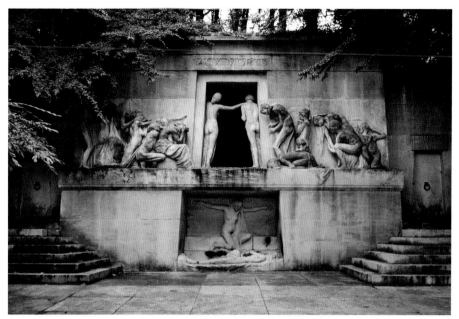

(JC)

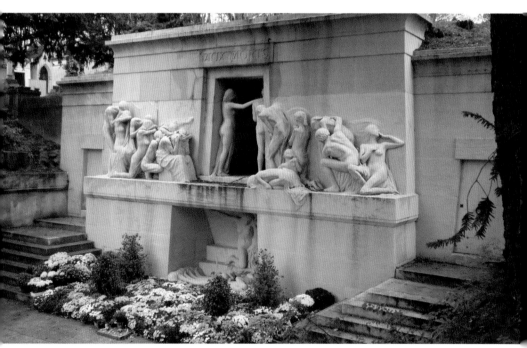

ABOVE: AUX MORTS MONUMENT AFTER RESTORATION.

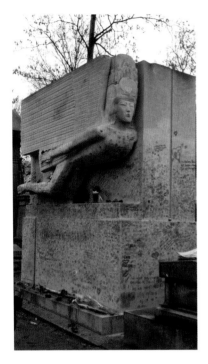

Yet, nature is only one of the destructive elements that threaten the thousands of sculptural and architectural treasures of Père-Lachaise. Well-meaning fans mark the tombs with graffiti, which damages the surfaces of stone. Thieves steal bronze sculptures to sell as scrap metal, leaving empty niches on the mausoleums of families. Some tombs are slowly disappearing due to the fragile materials used in their construction, vandalism, and acid rain.

Thankfully, there are those who care— and have the resources to help. If the tomb is considered important because of the person who is buried there or because of the historical or artistic interest of the tomb itself, it may be maintained and possibly restored by the City of Paris. A tomb without a family may also be maintained and restored through the efforts of a number of associations. A few of those include Les Appels d'Orphée[12], a group dedicated to the restoration of French monuments. Originally, the association, created in 1977, only took care of tombs of people associated with the opera, hence the reference to Orpheus the musician. Another association is the Association pour la conservation des monuments napoléoniens (ACMN),[13] or the Association for the Conservation of Napoleonic Monuments. That group works with another association called Souvenir Français, dedicated to the memory of soldiers fallen for France.

In France, monuments may be officially listed as historical monuments, which give them certain protection. There are two categories of historical monuments: classified (classés) and registered (inscrits): classified monuments are deemed of interest to the whole French nation and therefore they are the most strictly protected; registered monuments are deemed of interest to the region where they are situated and hence they are less strictly

protected. The entire cemetery was registered as a protected site in 1930. The Romantic section of the cemetery was classified in 1962. Some tombs dating from before 1900 were registered as historical monuments in 1983. Twelve were classified, and one registered.

It took the cooperative efforts of the French and Irish governments to repair Oscar Wilde's monument, which was being defaced with lip prints from misguided fans whose cosmetic kisses were harming the porous limestone sculpture. JimMorrison's grave and nearby

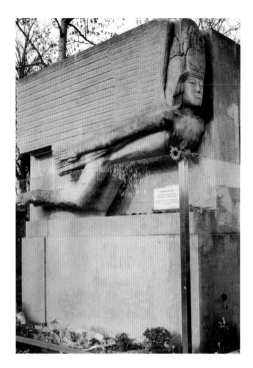

tombs suffered from endless graffiti, so that there are now protective barriers surrounding his burial place; a not-so-aesthetic but necessary solution.

The complete restoration of the neo-Gothic tomb of famed lovers Héloïse and Abélard was underwritten by the City of Paris. The restoration process poses an ongoing structural challenge due to its top-heavy architectural treatment and the need for its reinforcement.

Starting in 1984, the French Commission on Funerary Architecture (CAF) of the City of Paris has taken responsibility for restoring the tombs of Molière and La Fontaine, which were covered by a century's growth of lichen and moss. CAF has also overseen preserving the tomb of architect Alexandre Brongniart, the monument to Casimir-Périer located in the Grand Rond, the elaborate Dantan family tomb by sculpture Antoine Dantan, the life-size statue representing the allegory of pain as the widow of Sebastien Gourlot on his tomb, and the monument of Marshal Louis Suchet featuring a bas relief by sculptor David d'Angers. Many other significant tombs are protected through the historic designation, including those of composer André Grétry, and artists Théodore Géricault, Auguste Clésinger, Camille Corot, and Pierre-Paul Prud'hon.

TOP: WIDOW OF SEBASTIEN GOURLOT.

BOTTOM: CASIMIR-PÉRIER.

In addition to civic groups, individual families have mounted efforts to restore certain tomb. Pauline Duclaud-Lacoste, the great, great granddaughter of legendary French filmmaker Georges Méliès, spearheaded a successful crowdfunding campaign in early 2019 to restore his tomb in Père-Lachaise. Méliès was one of the pioneering figures of film, who is often credited as the man who single-handedly invented special effects in movies.

Duclaud-Lacoste gained approval from various key stakeholders, including the City of Paris, the commission of architecture and conservators, and the conservator of Père-Lachaise for the tomb's restoration. The project will take about ten days and cost $40,000 USD (the team of designated experts qualified to work in the cemetery are very expensive) to totally reconstruct the stolen iron posts and chain, clean the bronze bust and the grave stone, and rewrite the lettering on the tomb. She also raised an additional $8,000 toward the tomb's preservation over the next decade.

City of Immortals has a deep commitment to this important restoration and preservation effort and encourages all visitors to leave a floral offering if you wish, but please resist taking any souvenirs or marking a tomb in any fashion. Père-Lachaise was founded over 200 years ago. Its civic administrators are the guardians of centuries of immortals residing here. Let's ensure that its treasured monuments remain a destination for visitors of many lifetimes to come.

LEFT: COMPOSER ANDRÉ GRÉTRY.

RIGHT: MARSHAL LOUIS SUCHET (JC).

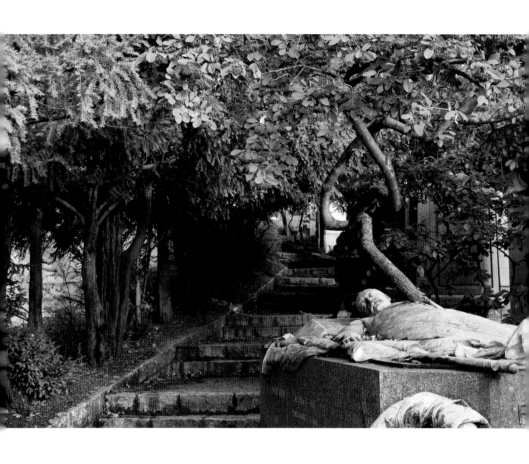

ACKNOWLEDGMENTS

Bringing *City of Immortals* to life has been a rewarding and life-changing adventure. My deepest appreciation goes to my friend and architectural writer Michael Webb, whose acting as editorial advisor on the project opened the door for my signing with publisher Gordon Goff. Thanks also go to Gordon and his dedicated team at Goff Books—Kirby Anderson and Brooke Biro. A reverent bow goes to my longtime writing mentor Terry Wolverton, along with thanks to Eric Howard, who helped bring my manuscript into final form, and thanks to my publicist, Katie Dunham, for spreading the news with such enthusiasm and expertise.

Words cannot express my gratitude for my esteemed collaborator, Joe Cornish. It's been a memorable photographic journey for us both. His early images of Père-Lachaise Cemetery over the years have stood in as my muse when I was not in Paris. Without cartographer Matt Zebrowski's superb graphic skills, I would have never been able to create the *City of Immortals* guide map.

My unwavering respect goes to my early champion John Russell, the late art critic of the *New York Times*, whose encouragement of my passion for Père-Lachaise began when I worked at the Corcoran Gallery of Art. Our friendship, based on our shared love of France, culture, and storytelling, continued for decades. John introduced me to Richard A. Etlin and his book *The Architecture of Death: The Transformation of the Cemetery in Eighteenth-Century Paris*, which served as my true north in writing about Père-Lachaise. Another significant influence was the late Patrick Bracco, head of the French Bureau of Historic Monuments, who first opened my mind and heart to the cemetery's rich history and artistic significance. Capturing some of the intimate voices of the residents in the cemetery was made possible through gracious meetings with Merlin Holland, Ray Manzarek, Alain Ronay, Bill Siddons, and Danny Sugerman.

It was an honor to have the support and cooperation of officials from the French government: François de Panafieu and Janic Gourlet, adjunct and

director, respectively, of Parks and Gardens and Green Spaces for the City of Paris, and Françoise France in that office—also Rene Maquer and Embarek Kari of the City of Paris. My deep appreciation also goes to Paul Brault and Jean Demorand, former heads of the Bureau of French Cemeteries, and the bureau's assistant director M. Auret; as well as Thierry Bouvier and Martine Lecuyer, past and present conservators of Père-Lachaise, and former assistant conservator Henri Beaulieu, and Biagio Milano and Azadeh Kavian, staff members at Père-Lachaise. I am further indebted to Fabienne Chaudesaygues and Christophe Piccinelli-Dassud, in the Department of Historical Monuments, Paris; Danica Zujovic at the Ministry of Fine Art, Paris; and Danet Nadège and staff at the Bibliothèque nationale de France.

Stateside, my thanks go to Juliette Salzmann, Laurent Devez, Adrien Sarre, and Adelaide Barbier, the former cultural attachés at the French Consulate in Los Angeles, and staff members Sophie Degat, Mathieu Fournet, Sophie Christophe, Antonia Rigaud and Soizic Pelladeau, who helped with numerous information requests and navigating the permissions and access to the cemetery from 6,000 miles away. I am also eternally grateful to Christian Morieux and Frazier Draper, cultural attachés at the French Embassy in Washington, DC, and New York, respectively, and their staff members M. Guyhenno and M. North, who made the crucial diplomatic introductions for me in the early 1980s, including those to Boutinald Rouele and M. Montoroso in Paris. Thanks as well to Elton Stepherson of the USIA in Washington, DC, and his colleague in Paris, Hélène Baltricitus. My gratitude also goes to the research staffs at the UCLA Special Collections Library, the West Hollywood Library, and City of Los Angeles Library. And, my deep appreciation to Air France for their support with my initial travel to Paris in 1982.

To family, friends, colleagues, and interns in the United States and France who helped with research, editing and translation, offered sage advice, generous hospitality, and unending encouragement over the past three decades, I cannot express how important your contributions have been. Thanks to my literary sister Kathleen, who supported my dream early on, and continues to be my number one booster; thanks to my fellow scribes in Terry Wolverton's group, *Cover to Cover: Writing the Book-Length Work;*

Pat Alderete, Annaly Bennett, Wendy Burg, Andy French, Layne Murphy, Rochelle Newman, Chris Offutt, Ramona Pilar, Kathy Talley-Jones, Belinda Vidaurri, Jeffrey Wolf, and Susy Zepeda; and to Lucy apRoberts, Marty and Don Baird, Marie Beleyeme, Molly Berke, Joe Binns, Fabrice Cahen, Paddy Calistro, Debbie Campbell, Jo Campbell, Michael Carlisle, John P. Collins III, Martin Cox, Arlette Crandall, Maia Danziger, Brigitte Dormont, Hunter Drohojowska-Philp, James Egan, Weba Garretson, Boris Geiger, David Godine, Laura Grover, Shelli Hall, Nancy Hardin, N.C. Heikin, Douglas Hill, Robert Hill, Daniel Horowitz, Julie Jones, John Kaye, Doug Keister, Sage Knight, Diva Lopato, Olivier Loudin, Harry Lunn, Jr., Barbara Mende, Kirk Mottram, Tim Page, Sierra Pecheur, Natalie de la Pre, Elizabeth Punsalan and family, Laura Raim, Sylvie Revillon, Bianca Roberts, Edward Robinson, Jill Schary Robinson, Henry C. Rogers, Hyman Rudoff, Mike Schuyt, Nathalie Seaver, Benno Sebastian, Roger Selleck, Steve Soper, Judith Teitelman, Emma Lew Thomas, Elin VanderLip, Christine Villeuve, Frank Weaver, Marcel Wepper, Mindi White, Allen Zadoff, Marc Zicree, Wenxin Zhang, and Pierre Zins.

Lastly, I owe a great debt to my father, Don Campbell, who in his last days gave me the best advice a daughter could ever have: "Never put off your dreams."

Resources

Aries, Philippe. *The Hour of Our Death*. Translated by Helen Weaver. New York: Oxford University Press, 1981.

Bahati, David. "The David Bahati Interview." Interview by Rachel Maddow. Aired June 12, 2011, on MSNBC. http://www.msnbc.com/rachel-maddow-show/the-david-bahati-interview.

Baldwin, Harry Eugene, "The King of Remembrance." *Frontiers*. (August 3, 2001).

Balzac. West Long Branch, New Jersey: KULTUR International Films. 2002.

Balzac, Honoré de. *The Wrong Side of Paris*. Translated by Jordan Stump. New York: Random House, 2004.

Barozzi, Jacques. *Guide des cimetières parisiens*. Paris: Editions Hervas, 1990.

Berger, Patrick. "Replanning of the 'Romantic' Sector at the Perè Lachaise Cemetery." *Domus*. (March, 1995).

Berteaut, Simone. *Piaf: A Biography*. New York: Harper & Row, 1969.

Beyette, Beverly. "On The Wilde Side." *Los Angeles Times*. (March 22, 1998).

Bloomberg News. "Modigliani Work Fetches $27 Million." *Los Angeles Times*. (June 20, 2006).

Brown, Frederick. *Père-Lachaise: Elysium as Real Estate*. New York: Viking Press, 1973.

Burke, Carolyn. *No Regrets: The Life of Edith Piaf*. New York: Alfred A. Knopf, 2012.

Butler, Patricia. *Angels Dance and Angels Die: The Tragic Romance of Pamela and Jim Morrison*. London: Omnibus Press, 1998.

Camfield, William A. *Max Ernst: Dada and the Dawn of Surrealism.* Houston: Menil Collection, 1993.

Charlet, Christian. *Le Père-Lachaise: Au coeur du Paris des vivants et des morts.* Paris: Gallimard, 2003.

Colette. *Earthly Paradise: Colette's Autobiography, Drawn from the Writings of Her Lifetime,* edited by Robert Phelps. New York: Farrar, Straus and Giroux, 1966.

Colvin, Howard. *Architecture and the After-Life.* New Haven and London: Yale University Press, 1991.

Cone, Michèle C. "Social Study." *ARTnews.* (December 2002).

Courthion, Pierre. *Géricault raconté par lui-même et par ses amis.* Geneva: Pierre Cailler, 1947.

Culbertson, Judi and Tom Randall. *Permanent Parisians.* Chelsea, Vermont: Chelsea Green, 1986.

Dansel, Michel. *Au Père-Lachaise.* Paris: Fayard, 1976.

De Botton, Alain. *How Proust Can Change Your Life.* New York: Pantheon Books, 1997.

De Mille, Agnes, *Dance to the Piper.* New York: Bantam Books, 1987.

Delacroix, Eugène. *The Journal of Eugène Delacroix.* Edited by Hubert Wellington. Translated by Lucy Norton. New York: Cornell University Press, 1980.

Densmore, John. *Riders on the Storm: My Life with Jim Morrison and The Doors.* New York: Delacorte Press, 1991.

Duncan, Isadora. *My Life.* New York: Liveright, 1927.

Eitner, Lorenz. *Géricault.* Los Angeles: Los Angeles County Museum of Art, 1971.

Epstein, Jacob. *Let There Be Sculpture*. New York: G.P. Putnam and Sons, 1940.

Escholier, Raymond. Delacroix: *peintre, graveur, ecrivain*. Paris: H. Floury, 1929.

Etlin, Richard A. *The Architecture of Death: The Transformation of the Cemetery in Eighteenth-Century Paris*. Cambridge, Massachusetts: MIT Press, 1983.

Fleming, John, Hugh Honour, and Nikolaus Pevsner. *The Penguin Dictionary of Architecture*. Baltimore, Maryland: Penguin Books, 1966.

Forgey, Benjamin. "Modigliani, the Eternal Bohemian." *Washington Post*. (December 11, 1983).

Gaiman, Neil. *The Graveyard Book*. New York: HarperCollins, 2008.

Gardiner, Stephen. *Epstein: Artist against the Establishment*. New York: Viking, 1992.

Goldberg, Jonah. "Jonah Goldberg: Taken in by 'Gay Girl.'" *Los Angeles Times*. (June 14, 2011).

Grant, Annette. "The Marriage à Trois That Cradled Surrealism." *New York Times*. (April 3, 2010).

Healey, Catherine, Karen Bowie, and Agnès Bos. *Le Père-Lachaise*. Paris: Action Artistique de la Ville de Paris, 1998.

Holland, Merlin. *The Wilde Album*. New York: Henry Holt, 1997.

Holland, Merlin. *The Wit and Humor of Oscar Wilde*. Edited by Alvin Redman. New York: Dover Publications, 1952.

Holland, Vyvyan. *Oscar Wilde: A Life in Letters*. London: Thames & Hudson, 1960.

Holt, Elizabeth Gilmore, ed. *From the Classicists to the Impressionists: Art and Architecture in the Nineteenth Century*. Garden City, New York: Doubleday, 1966.

Honigmann, Heddy. *Forever*. Icarus Films, 2006.

Hopkins, Jerry and Danny Sugerman. *No One Here Gets Out Alive*. New York: Warner Books, 1980.

Horne, Alistair. *Seven Ages of Paris*. New York: Knopf Doubleday, 2003.

Huxley on Huxley. Panel Discussion and Film Excerpts with Don Bachardy, Ann Louise Bardach, Mary Ann Braubach, and John Densmore. "Aloud Series." Library Foundation of Los Angeles. June 21, 2011.

Huyghe, René. *Delacroix*. London: Thames & Hudson, 1963.

Janson, H.W. *History of Art*. Third Edition. New York: Harry N. Abrams, 1986.

Jones, Barbara. *Designs for Death*. New York: Bobbs-Merrill, 1967.

Jullian, Philppe. *Oscar Wilde*. Viking Press: New York, 1968.

Keister, Douglas. *Stories in Stone: A Field Guide to Cemetery Symbolism and Iconography*. Salt Lake City, Utah: Gibbs Smith Publisher, 2004.

Lange, Monique. *Piaf*. New York: Seaver Books, 1981.

Laqueur, Thomas W. *The Work of the Dead: A Cultural History of Mortal Remains*. Princeton, New Jersey: Princeton University Press, 2015.

Lavin, Sylvia. *Quatremère de Quincy and the Invention of a Modern Language of Architecture*. Boston: MIT Press, 1992.

Linden-Ward, Blanche. *Silent City on a Hill: Picturesque Landscapes of Memory and Boston's Mount Auburn Cemetery*. Columbus, Ohio: Ohio State University Press, 1989.

Manzarek, Ray. Light *My Fire: My Life with The Doors*. New York: G.P. Putnam's Sons, 1998.

Masters, Edgar Lee. *Spoon River Anthology*. New York: Collier Books, 1962.

Matson, Katinka. *Short Lives: Portraits in creativity and self-destruction*. New York: William Morrow, 1980.

Maurois, André. *Prometheus: The Life of Balzac.* Translated by Norman Denny. New York: Harper and Row, 1965.

Mills, Cynthia. *Beyond Grief: Sculpture and Wonder in the Gilded Age Cemetery.* Washington, DC: Smithsonian Institution Scholarly Press, 2014.

Oscar Wilde and the Culture of the Fin de Siècle. Conferences at William Andrews Clark Memorial Library, Los Angeles, Jan 22–23, March 6–7, April 9–10 , May 14–15, 1999.

Pennington, Michael. *An Angel for a Martyr: Jacob Epstein's Tomb for Oscar Wilde.* Reading, England: Whiteknights Press, 1987.

Piaf, Edith, with Jean Noli. *My Life.* Translated by Margaret Crosland. London: Peter Owen, 1990.

Powers-Douglas, Minda. *Cemetery Walk: A Journey into the Art, History and Society of the Cemetery and Beyond.* Bloomington, Indiana: Author House, 2005.

Remembering Oscar Wilde. Symposium at UCLA William Andrews Clark Memorial Library, Los Angeles, November 20, 2000.

Robinson, David. *Beautiful Death: The Art of the Cemetery.* Essay by Dean Koontz. New York: Penguin Studios, 1996.

Robinson, David. *Saving Graces.* New York: W.W. Norton, 1995.

Rosenthal, Léon. *Géricault.* Paris: Librairie de l'art ancien et moderne, 1930.

Saint-Bris, Gonzague. "Confessions of a Proustomaniac." *Elle International.* (Fall/Winter 1984).

Secrest, Meryle. *Modigliani: A Life.* New York: Alfred A. Knopf, 2011.

Segal, Lewis. "Still a Step Ahead." *Los Angeles Times.* (December 25, 2005).

Sichell, Pierre. *Modigliani.* New York: E.P. Dutton, 1967.

Soper, Steve, with Marie Beleyme. *A Guide to the Art in Paris Cemeteries Père-*

Lachaise. Third edition. Createspace Publishing, 2017.

Southami, Diana. *Gertrude and Alice.* New York: HarperCollins, 1991.

Steegmuller, Francis. *Apollinaire: Poet among the Painters.* New York: Penguin Books, 1963.

Vogel, Carol. "$68.9 Million Modigliani Gets Auction Season Off to a Healthy Start." *New York Times.* November 2, 2010.

Walker, Alan. *Fryderyk Chopin: A Life and Times.* New York: Farrar, Straus and Giroux, 2018.

Wilde Archive, The. Joseph Bristow, Chair. Symposium at William Andrews Clark Memorial Library, Los Angeles, May 29–30, 2009.

Winwar, Frances. *Oscar Wilde and the Yellow Nineties.* Garden City, New York: Blue Ribbon Books, 1942.

Wright, Richard. *Black Boy (American Hunger).* New York: Library of America, 1993.

Zamoyski, Adam. *Chopin: A New Biography.* Garden City, New York: Doubleday, 1980.

Bios

PHOTO BY MARTIN COX

CAROLYN CAMPBELL—AUTHOR AND PHOTOGRAPHER

Carolyn Campbell was born in Washington, DC, has lived in Paris, and is now a resident of Los Angeles. A published writer and an exhibited photographer, her fascination with Père-Lachaise was kindled on a first visit to Paris in 1981. With the support and encouragement of her mentor, John Russell--the late *New York Times* art critic--she embarked on her research and photo documentation of the cemetery. A summa cum laude graduate of the Maryland Institute College of Art, she has been working as an arts and communications specialist for over thirty years. She has held executive positions with the Corcoran Gallery of Art, the American Film Institute, and the UCLA School of the Arts and Architecture, where she was also editor of *UCLA Arts* magazine.

Joe Cornish—contributing photographer

Joe Cornish is based in the U.K. and has shot travel, cultural, and landscape subjects for thirty-six years. Since his first photographic explorations in Père-Lachaise with Carolyn Campbell in 1982 he has contributed to numerous travel books as well as writing his own on landscape photography. An Honorary Fellow of the Royal Photographic Society (RPS), he is now Chair of the RPS Fellowship Board.

End Notes

1 "2.329 euros au Père Lachaise," *Journal du Net*, accessed March 22, 2019, http://www.journaldunet.com/economie/enquete/concession-cimetiere-les-plus-cheres/1-pere-lachaise.shtml.

2 Richard A. Etlin, *The Architecture of Death: The Transformation of the Cemetery in Eighteenth-Century Paris* (Cambridge, Massachusetts: MIT Press, 1983), 116.

3 Edith Piaf, with Jean Noli. *My Life*. Translated by Margaret Crosland (London: Peter Owen, 1990), p. 34.

4 Piaf, *My Life*, p. 99.

5 Janet Flanner, "Isadora," *New Yorker*, January 1, 1927, https://www.newyorker.com/magazine/1927/01/01/Isadora.

6 Lewis Segal, "Still a Step Ahead." *Los Angeles Times*, December 25, 2005, p. 2.

7 Tama Lea Engelking. "Anna de Noailles Oui et Non: The Countess, the Critics, and la poésie feminine," *Women's Studies: An Interdisciplinary Journal 23 no. 2* (1994), pp. 95-111, https://www.doi.org/10.1080/00497878.1994.9979014.

8 Steve Soper, "Postcard from Paris: Bibesco and Noailles," *Paris Cemeteries*, May 28, 2018, http://www.pariscemeteries.com/news-1/2018/3/15/postcard-from-paris-bibesco-and-noailles.

9 Agnes Mongan, introduction to *Daumier in Retrospect*, 1808–1879, The Armand Hammer Foundation exhibition catalogue, 1979.

10 Jean Auguste Dominique Ingres, *Artble*, https://www.artble.com/artists/jean_auguste_dominique_ingres.

11 "Sādegh Hedāyat: The foremost short story writer of Iran," Iran Chamber Society, http://www.iranchamber.com/literature/shedayat/sadeq_hedayat.php.

12 http://les-appels-d-orphee.blogspot.com/.

13 http://napoleon-monuments.eu/ACMN/.

ILLUSTRATIONS

© photographs by Joe Cornish (JC) pages: image opposite Title Page, 18, 24, 26, 27, 29, 31, 32, 39, 40, 41, 43, 45, 46, 53, 56, 64, 74, 82, 85, 106, 133, 134, 143, 145, 148, 160, 165, 175, and 179.

© photographs provided with permission of the Bibliothèque nationale de France (BnF), pages: 21, 22, 36, and 37.

© photographs used with permission of John Punsalan (JP) pages: 13, 14, and 36.

© all other photos by the author, Carolyn Campbell.

Index

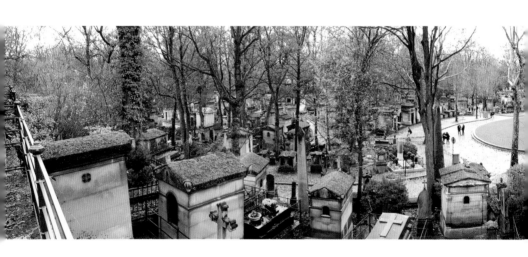

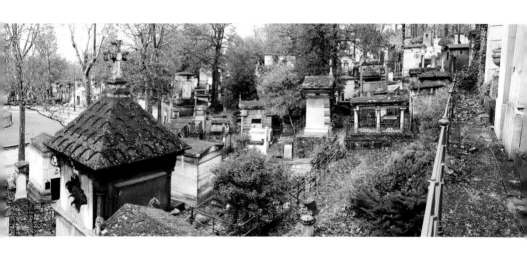

Published by Goff Books, an Imprint of ORO Editions.
Executive publisher: Gordon Goff.

www.goffbooks.com
info@goffbooks.com

Graphic Design: Brooke Biro
Text: Carolyn Campbell
Goff Books Project Coordinator: Kirby Anderson

10 9 8 7 6 5 4 3 2 1 First Edition

Library of Congress data available upon request. World Rights: available.

ISBN: 978-1-943532-29-2

Color separations and printing: ORO Group Ltd.
Printed in China.

International distribution: www.goffbooks.com/distribution

ORO Editions makes a continuous effort to minimize the overall carbon footprint of its publica-
tions. As part of this goal, ORO Editions, in association with Global ReLeaf, arranges to plant
trees to replace those used in the manufacturing of the paper produced for its books. Global Re-
Leaf is an international campaign run by American Forests, one of the world's oldest nonprofit
conservation organizations. Global ReLeaf is American Forests' education and action program
that helps individuals, organizations, agencies, and corporations improve the local and global
environment by planting and caring for trees.